THE

Anointing Exposes

THE DEEDS OF THE FLESH

For if he lives after the flesh, ye shall die: but if ye through the Spirit
(Anointing) do mortify the deeds of the body (flesh), ye shall live
—Romans 8:13.

MERITS HENRY

Many of our inner conflicts are not going to cease until the character of Christ Jesus is formed in our hearts.

THE
Anointing Exposes
THE DEEDS OF THE FLESH

*For if he lives after the flesh, ye shall die: but if ye through the Spirit
(Anointing) do mortify the deeds of the body (flesh), ye shall live
—Romans 8:13.*

MERITS HENRY

WESTBOW
PRESS
A DIVISION OF THOMAS NELSON

WestBow Press books may be ordered through booksellers or by contacting:

WestBow Press
A Division of Thomas Nelson
1663 Liberty Drive
Bloomington, IN 47403
www.westbowpress.com
1-(866) 928-1240

ISBN: 978-1-4497-1220-4 (sc)
ISBN: 978-1-4497-1221-1 (dj)
ISBN: 978-1-4497-1219-8 (e)

Library of Congress Control Number: 2011921668

Printed in the United States of America

WestBow Press rev. date: 2/17/2011

This book is dedicated to my family.

To my spiritual father, Bishop Carl Wilson, whose love, guidance, and mentorship have been a great tower of strength; whose words of wisdom hitherto transformed my life from nothing to something, failure to success, and pit to the palace. Thanks for believing in me and having the courage and patience to put up with me when I could not see my true purpose and destiny. With your support and prayers, I am what I am today simply because of the spirit of wisdom that God gave you, which prepared me for Ministry.

To my parents, Delpha and Adonijah Henry, whose ray of hope shined, believing that one day God would turn my life around. I love you, Mom and Dad, for all the years of praying and support that I have received. You are two in a million; indeed, you are the best parents in the world.

My first daughter, Raar Henry, whose life stories also encouraged my heart to write this book.

And most of all, to the lover of my life, my queen Rashemia Henry. Our union together in the Lord has blessed us with two wonderful children, Ramere and Azzan Henry. You are an outstanding mother who has ceaselessly devoted your time and love for our children.

"Rash," thank you for standing by my side and being an encouragement to me in the good times and offering comfort in the bad times. You are the greatest gift from God. I love you.

Contents

Part 2

The Spirit of Jezebel and Ahab

Preface

Double Portion Inheritance

This is the beginning of miracles did Jesus in Cana of Galilee, and manifested forth his glory; and his disciples believed on him (John 2:1–11).

According To Rod Parsley (The Double Portion Anointing, 2002), "An inheritance is only valuable if you receive it and use it."

Every born-again believer is entitled and has a right to this birthright inheritance. It was promised and later prophesied by Joel in 2:23–29. The very first miracle recorded in the word of God is when Jesus performed the miracle of turning water into wine (John 2, as above).

As a people birthed with purpose, God has reserved the best for the last to display his tangible anointing power to a dying world. The anointing is that divine inducement from above, and not a desire of emotional feelings. It comes not with years of experience, status, and articulates. But rather it is given by laying aside every weight and sin that easily besets us.

He has placed a "now power" (Ephesians 3:20) on the inside of you to defeat your adversary. This power is actually on the inside of you right now. This is the beginning of miracles concerning you—just believe!

This is your hour of power.

It is my heart's desire that every born-again believer will be ready to experience this mighty move of God upon his or her life. Times are too serious for us to sit quietly under the "Juniper tree" waiting to hear from the prophet of old, which seemingly doesn't like you because of the tangible

anointing on your life. God has not given you (the church) the spirit of fear but of power, love, and of a sound mind.

Why? From the beginning of time, there has been a struggle for the double portion of God's blessing destined for the church. We have seen this in the lives of Jacob and Esau, Perez and his brother, and Elisha. They all desired a double portion of Elijah's spirit before he was taken away to heaven.

Since the resurrection of Jesus Christ, the church has been in a fight to receive the double portion inheritance that rightfully belongs to her. But I believe we are at a prophetic crossroad in history to witness a people with a new birth—destined to walk in a double portion of his spirit, just as Elisha received a double portion of Elijah's spirit. As part of the church of the firstborn, God has saved us, the best, for the last.

Therefore, I charge every believer to refuse to settle for the mediocre. We must bring every thought captive from being anything less than Holy Ghost possessed. We must desire nothing less than the anointing that destroys yokes of bondage, opens blind eyes, straightens crippled limbs, mends broken homes, and delivers every captive.

My heart's cry is "Get ready!" There is a storm of revival coming! There is a double portion of the Holy Ghost wine, oil, and anointing waiting for you. The book of Joel proclaims it this way: "Be glad then, ye children of Zion, and rejoice in the Lord your God: for he hath given you the former rain moderately, and he will cause to come down for you the rain, the former rain, and the latter rain in the first month. And the floors shall be full of wheat, and the fat shall overflow with wine and oil" (Joel 2:23–24).

God's word promises that there will be an overflow, or a double portion, of wine and oil (or anointing) coming your way in one month. That's a double blessing! This double portion is waiting for you. It is part of your inheritance through Christ Jesus. It will show you how to walk in the anointing of the Holy Spirit and do greater works than that of the risen Messiah.

In this year of prophetic destiny, the Lord is giving birth to a generation of people who will learn to live, move, and have their being in the spirit realm because of the anointing upon their lives. Will you answer the call

to be part of this remnant, destined to walk in the double portion of God's spirit?

This is your hour of power! This is your day to receive your double portion.

The wiles of the devil are very cunning, and that's why it is of paramount importance to receive this double portion so that we can stand triumphant and say we are well able to overcome. Beware! The flesh will most definitely battle with the spirit of God, but the greater one will come out victorious. As we are preparing also, let us remember persons, such as "false prophetess Jezebel" and "compromising Ahab," who will have their own agenda against the strong tower of God.

Receive Your Double Portion.

Instead of your shame you shall have a double portion, instead of dishonor you shall rejoice in your lot; therefore in your land you shall posses a double portion; yours shall be everlasting joy (Isa. 61:7 RSV).

But my horn shall be exalted like the horn of an unicorn; I shall be anointed with fresh oil (Ps. 92:10).

Thou anointed my head with oil; my cup runneth over. Surely goodness and mercy shall follow me all the days of my life: and I will dwell in the house of the LORD for ever (Ps. 23:5b–6).

I want to add my faith to yours and believe with you that these words will take root within your spirit. As we agree together, I believe you will reap the greatest miracle you have been waiting for— you will receive *your* double portion.

Please pray with me:

Father, I thank you that in this hour of double, I pray that you will increase this person's revelation and anointing. I believe you to double their freedom and the resurrection power of Christ in their lives. I declare even now, as you read the first page of this book, that your life will never

be the same again. As the word of God says, beloved, I wish above all things that thou may prosper and be in good health, even as your soul prospers (3 John 2). I speak more than enough, abundance, overflowing, increase, extensions of territories, and favor of prophetic releases into your life right now.

In the name of Jesus, I release to you that which I have received, an impartation of the spirit of faith to know in your weakest moment Jesus is praying for you. Even now, He is calling your name, refusing to allow your faith to fail. Your greatest battle means your greatest victory.

May you know and experience the double portion of God's peace, presence, and miracle-working power in your life even right now. I believe it to be so, in the mighty name of Jesus, Amen.

Merits Henry

ACKNOWLEDGEMENT

To God be the glory; great things he has done!

I humbly acknowledge God, the Lord Jesus Christ, who's the author and finisher of my life, for deeply inspiring me to write this book.

With deep gratitude, I want to profoundly thank Mrs. Ericka Daniel and Sis R. Barnes who, because of their sincere compassion and faithfulness, have assisted to bring this message to the world. I am forever grateful to you and will forever express kindness to you and uplift you in my prayer. Also to the multitude of friends and educators who have contributed and encouraged me to complete this work.

To Mr. Roosevelt Cowan, for his excellent ideas and influence that continues to motivate me to soar to new heights.

To my prayer mother, Evangelist Carol Graham, whose times of intercession have given me new vision, zeal, and determination to continue pursuing this book.

I am especially grateful to my editors who have work diligently to complete this book. Thank you for making this book a great success.

God bless you all!

INTRODUCTION

This book is about spiritual warfare. The context is God-inspiring and directed divinely by the Holy Spirit. Many things in this book are to further open your eyes to much deeper revelation and truth concerning his plans and purpose for your life.

The book is divided into two main parts, namely "The Anointing versus Lucifer and the Flesh" and "The Spirit of Jezebel and Ahab." According to the name of the book, "The Anointing Exposes the Deeds of the Flesh," the parts previously named will be clearly interrelated with definitions, terminology, typology, and exegesis. All quotations from Scripture are from the authorized King James Version unless otherwise noted.

In regard for integrity and loyalty to the ministry of God, please note that changes are made in relation to my life testimonies, experiences, and people's names.

As you read this book, it is my prayer that you will become increasingly aware of the wiles of the devil through the tangible anointing on your life.

May you be transformed from glory to glory.

やめ

PART 1

The Anointing Versus Lucifer and the Flesh

やめ

One

The Anointed Cherub

Since the fall of Lucifer, "the anointed Cherub," there has been a struggle in the Christian arena to receive the double portion anointing. Mighty men have become complacent and in so doing have compromised the truth. Unfortunately, the love of many has become cold, and the zeal of the Pentecostal anointing is no longer present in the pulpit. The glory of the Lord has departed. The divine insignia, which is said to be the spiritual staff of office, an emblem of authority and a symbol of God's presence, is fading away. The glory of the Lord has now become *Ichabod* instead of *Ebenezer*. The road on which these happenings are driven is called the *mystery of iniquity*. The mystery of iniquity has thus revealed itself through the entrance of pride and a rebellious spirit simply because of the powers of iniquity, influence, illusion, and witchcraft in conjunction with manipulation, intimidation, and domination. These have been launched out into the world by the enemy's cohorts. Satan is a master strategist. He has a strategy that is aimed at diverting us from fellowship, thus preventing us from receiving from God. His mission is to scare, manage, and overpower us.

The anointed cherub was appointed by God especially to minister in triune presence. He was chosen above the others by the Godhead for this particular task. Gifts were given to him to entertain the Father during special hours of worship. Lucifer had it all. His task was one of a kind. His administrative roles were spectacular. He was given pre-eminent rights to organize the choir for these occasions, to chose and plan worship events wherein the anointing would usher in the presence of worship. Cherubim, as recorded in the Bible, operate as the primary guardians to the presence of God.

In the Garden of Eden after the exposition of sin, God placed cherubim in the garden with flaming swords as a source of protection. They were highly trained officers with ranks of seniority (see Genesis 3). He was privileged to enter the throne room of God at any time. No one was closer to the Godhead than Lucifer. He entered the presence of God at will. Perhaps he grew so accustomed that he took this privilege for granted.

⁎⁎⁎

Thou are the potter, I am the clay. Only the maker can determine your shaping.

We are the creation for creativity, not the creator of the creation.

⁎⁎⁎

Perhaps he entered without a cause and presumptuously tried to gain favor by doing a little bit more to please God. According to the old adage, "Familiarity breeds contempt and supposition opens wounds of deception." People with such a presumptuous attitude easily become too familiar with the presence of the Lord, and, as a result, the reverential fear no longer exists in the house of God. One has to be careful that being overzealous for God doesn't lead us in the wrong path of servant hood in the Master's vineyard. One can easily miss the ultimate reason for worshipping God if too much fire is seen and no results. Quite often, we purposely come to church when we feel like, do our own thing, and have our own "service group." This being the case, the follies of *self-will* have just won. The line must be drawn in holiness unto the Lord. Being too friendly is detrimental to the gifts of Christ, especially regarding the role of pastoral care and counseling. Rebuke and discipline will be hard for the servant of God because he or she has created a gap for such disciplinary action to carry out.

Even though Lucifer is in a fallen state, he still enters the presence of God to accuse believers before the Father. *"For the accuser of the brethren is cast down, which accused them before our God day and night"* (Rev. 12:10). He still sees himself as the anointed cherub delegating to the angels. One thing about Lucifer is that he takes pleasure in dictatorship (since his nature is prone to give orders and to be in command). If a boss fires you for inconsistency, there is absolutely no way you can make claims or wrongfully accuse the boss regarding what he did—you will be seen as being disrespectful and presumptuous. The boss will think that you are trying to overpower him regarding his decision. Chances are you will be fired and have to seek another job! The devil doesn't see it that way. Certainly he forgot who created him.

The main passage regarding the life of Lucifer is Ezekiel 28. This speaks about his responsibilities.

> Thou art the anointed cherub that covereth; and I have set thee so: thou wast upon the holy mountain of God; thou hast walked up and down in the midst of the stones of fire. Thou was perfect in thy ways from the day that thou was created, till iniquity was found in thee (Ezek. 28:14–15).

> Remember now thy creator in the days of your youth, while the evil days come not, nor the years draw nigh, when thou shalt say, I have no pleasure in them (Eccl. 12:1).

God created Lucifer specifically for worship and not for rule or headship. God only gave man dominion to rule on the earth. Man was given a direct responsibility. So it was with Lucifer. He was given a designated mission and that is to be a worship leader, for *"I have set thee so."* He was given everything. The ingredients of worship were provided. He was given the "wisdom for worship" along with perfection for worship, beauty for worship, anointing for worship, and other necessary tools for worship.

The workmanship of tumbrels and pipes were prepared for you on the day you were created.

He was under the headship of his overseer, God, and therefore had to abide by the teachings and instructions of his overseer. It is pertinent that we stick to the assignment! I was once told by one of my members, "I am seeing further than you; you are not seeing the things that I am seeing." I was consoled with a comforting inspiration from the Holy Spirit regarding what I was told. As I prayed about it, in response God said, "I have assigned you as a shepherd over the flock, primarily to guide and lead them to the Promised Land." He confirmed this in my Spirit as I examined a few of the leaders in the Bible: Moses, Joshua, and King David. The spirit of God said to me, "Lucifer was not greater than God or else he would have overpowered God." The individual who had spoken to me is a prophetess, but her statement was wrong though not incorrect. It wasn't justifiable. You cannot be greater than your shepherd. You cannot be greater than the

Leadership is not membership as well as membership is not crowd.

master of creation. The point here is Lucifer thought that he could be greater than God. *"I will ascend into heaven and I will exalt my throne above God."* God will for sure reveal some things that your pastor will not see only if God allows it, but it has nothing to do with you seeing further than your pastor—you are putting yourself in *hot water.* Whatever he shows, you should bear connection and confirmation to someone in the pew or pulpit.

Lucifer was created to lead worship, not to be a ruler over worship. We are called and hereby given the privilege to serve in designated service for the Lord. We are not called to dominate that office in any superiority of ranks but to serve as unto God with humility. Too many times, we serve in other offices, which we are not called to occupy, and as a result we miss the mark of our true calling. Lucifer forgot his job description that was assumingly given to him the very day he was created. Gifted and reliable cherub he was, Lucifer was ranked among great authorities. Because of his rights to enter the presence of God as he so desired, he had the opportunity to communicate with the angels as well as the Trinity. Leadership is not membership and this is what had overtaken Lucifer; he became so accustomed with some of the angels telling him how beautiful the music and the worship were. He was probably told, "Your music was great, do it again!" "I like the way you sing and worship." As a result of self-praise and glory, the heart of pride was formed and later denoted self-exaltation.

Leadership is not membership as well as membership is not crowd.

The spirit of Korah is a spirit that when manifested deposits rebellion and pride. This spirit was at work when God kicked Lucifer out of heaven.

In my first year after assuming pastoral responsibilities, the Lord led me to minister at a particular church where the voice of God spoke to me to tell the people that three spirits are on the island—the spirit of pride, spirit of greed, and spirit of immorality (fornication and adultery). This word was confirmed that night as we wrestled against the power of darkness. Soon after that, the Lord led me on twenty-one days of fasting and prayer. He spoke to me again about pride on the island and in churches. In the book of Numbers, 16:1–50, the spirit of pride was among the children of Israel; it dwelt in the house of Korah, where Dathan and Abiram joined forces against Moses and Aaron in lethal combat for superiority. They claimed to be holy and more sanctimonious than the priest and 250 prominent

Israelites who dedicated their time in intercession before the Lord. Hence, they coveted Moses for his position. This type of spirit has no reverence or respect for leadership, and behaves as though it doesn't matter if God ordain you to be the leader or not. The spirit of Korah always seeks to be promoted by means of domination within the respective community. Moses, when he heard of Korah's plans to reign as leader, humbled himself more and more, seeking the Lord for direction concerning the correct approach to be taken. Humility is a weapon that destroys the spirit of pride.

Humility is a weapon that destroys the spirit of pride.

In the first unit of the chapter, Korah rebels against the Lord by gathering his troops, (Num. 16:11). In the remaining verses, he gathered against Moses and Aaron (Num. 16:42). It is extreme and presumptuous to go against God and the man of God; this may eventually lead to failure. This shows the defiant attitude that Korah had as he totally disregarded God and the servant of God. On one occasion, I was doing a radio program about the life of Samson and Delilah when I discovered in the story that sin offers three things: sin blinds, sin binds, and sin grinds. So is the same with pride. Pride blinds the mind in such a way that we get puffed up a different nature that alters one's personality. When this happens, the proud individual thinks of himself more highly than others, but God forbid!

ജ)ൽ

Humility is a weapon that destroys the spirit of pride.

ജ)ൽ

Disrespecting God and leadership is a serious sin in the Bible, and if anyone has done this, it is imperative that he or she repents immediately before the wrath of God comes down on him or her. I have been to many churches and have seen this spirit in operation and it is out of context with the demonstration of the Holy Spirit. A friend of mine who is a pastor invited me to his church, and while the moderator was administering service protocol he turned the greeting remarks into a sermon. The pastor kindly wrote on a piece of paper and politely reminded the moderator that there was a guest speaker who was invited to minister. Believe it or not, the moderator (an officer of the church) disrespected the pastor in the open service. Out of wisdom, all the pastor did was to humbly take his seat. Where was the spirit of wisdom in the manner in which the moderator led

the service? Should he have changed the greetings to a sermon, missing the complete essence of the day's service? Was he overly zealous?

Korah missed the revelation and did contrary to his folly ways. He demonstrated no meekness to God and Moses. He wasn't teachable. He was uncouth and rebellious. Moses was one of the meekest men that ever lived (Num. 12:3), and he was always begging God for mercy. He was never too ashamed to repent rather than stand in pride like Korah did.

A proud person can never accept correction or criticism. Instead he or she is always quick to get defensive, refusing to apologize or say, "I'm sorry." In ignorance, pride places you above others. However, God says that He resists the proud but gives grace to the humble. A proud person is a troublemaker who is often found using words to blast people in a *rash and heady* manner. Pride finds it difficult to submit to God and His authority; it likes to glory in self-love and self-hatred (which gives the appearance of humility), demanding atonement for self rather than picking the beam out of his or her own eye in repentance. This spirit manifests itself in an awful manner leaving disgrace, wounds, and hurt in the path of those who it has encountered.

> Galatians 6:3 says, "If any man thinks himself to be something, when he is nothing, he deceiveth himself."

Pride is ignorance that seeks to place you above others.

When pride is manifested around you, simply get out of that community of people, hold your peace, and let the Lord fight the battle. Before long, this spirit of pride will transfer on you—you need to get out!

The word of God warns strongly against this attitude in churches today.

> "Wherefore let him that thinketh he standeth take heed lest he fall" (1 Corinthians 10:12).

> "Be not deceived; God is not mocked: whatsoever a man soweth, that he shall also reap" (Galatians 6:7).

> "For he that sows to his flesh shall of the flesh reap corruption; but he that sows to the spirit shall of the spirit reaps life everlasting" (Galatians 6:7–8).

"He that exalteth himself shall be abased, and he that humbleth himself shall be exalted" (Luke 14:11).

ℰℭ

Separate yourself from pride (get away from the dwellings of Korah, Dathan, and Abiram) and the Lord will not consume you instantly.

ℰℭ

Solomon, the wisest man, also warns believers about the spirit of pride:

"Pride goes before destruction; and an arrogant spirit before a fall" (Proverbs 16:18).

"Better to be lowly of spirit with the humble than to divide plunder with the proud" (Proverbs 16:19).

Two

Created, Not Made

Let's revise the principal character of Lucifer in Ezekiel 28. The distinctive difference between Lucifer and man is summed up in these three words: *"created and made."*

Man was both created and made. Lucifer was only created. The word *created* is from the Hebrew word *bara,* which means to create from nothing. And the word *made* is from the Hebrew word *asa,* which means "to form from something that is already created." Therefore, man is the combination of parts that were from nothing and things that were already made, according to the great theologian Myles Munroe.[1] This describes the mystery of man's production spirit being as a source directly from God, making man a composite of the nature, attributes, and character of the maker. While on the other side of the coin, Lucifer was created but not made in the image of God. He was created from nothing. We are not like God as the world thinks; we are the image of God. He was probably spoken into being.

Anytime in life when we started to take the glory for ourselves, we will definitely experience subjugation like Lucifer. The Bible says we are the sheep of his—Christ's—pastures. Personal pronoun is only designated to Christ's; any other uncouth behavior out of that perspective is pride. The question is *Who created whom?* We tend to easily forget who created whom— God said let there be and there was in the beginning God created the Heaven and the Earth (Genesis 1). God's creations were before you and me. He made and created us to be a part of this mystery. We cannot lose sight of this very fact. The structuring of leadership in the church, if not prayerfully considered, opens the heart up to pride. The sub-

1 *Rediscovering the Kingdom.*

headship in churches is very dangerous and can be domineering when we lose sight of the vision of God for ownership and not stewardship. We are stewards and not owners to any ministry to which God calls. We know everything belongs to God, but God always appoints leaders; someone to be the head, the under-shepherd so to speak. The ministry does not belong to that person but to God who ordains such an individual. The business administration of life does the same by nominating persons in offices.

We were made unconditional before God in the eternity counsel of the Godhead; purpose, preordained, elected and chosen as his workmanship until sin bridges the relationship of unconditional covenant to a covenant of condition where man is now given a promise that is primarily governed by his obedience.

> According as he hath chosen us in him before the foundation of the world, that we should be holy and without blame before him in love (Ephesians 1:4).

> For we are his workmanship, created in Christ Jesus unto good works, which God hath before ordained that we should walk in them (Ephesians 2:10).

> And the very God of peace sanctify you wholly; and I pray God your whole spirit and soul and body be preserved blameless unto the coming of our Lord Jesus Christ (1 Thessalonians 5:23).

Jesus Christ declares authoritative ownership in the gospel of Matthew 16:18. *"Upon this rock I build my Church."* When Jesus told Peter that he would build his church upon a rock, he did not mean that he would build his church upon Peter, whom many thought was the first pope. On this ground, the Roman Catholic has erroneously taught that Peter is the foundation of the church; hence, he became the first pope. Peter was never the pope and Jesus would never build a church on a mortal man who was fragile and incapable, who would later deny Jesus. He was going to build his Church upon Peter's confession of the deity of Jesus. It was upon this truth that Jesus Christ is the Son of God that the church would be built, declaring Jesus as the savior of the world universal. Jesus was going to build his Church upon a rock. A rock is a solid foundation that is firm, strong,

and lasting to undertake any pressure, storm, hurricane, wind, etc. so that the gates of hell, which will attempt to destroy it, will not prevail.

A rock is not on the same ground level with the world, so is the church of Jesus Christ. It will stand tall and strong against principalities in high places. It will not sink nor go under, but it will stand tall so that the world can see the shining light of purity and righteousness, that Jesus Christ is Lord.

He that exalted himself shall be abased. Any authority based in sedition or insurrection is rebellion. All rebellions are rooted in pride. And this type of illegitimate influence is contrary to Scripture. Any pastor who thinks that he cannot be corrected, reflect the attributes of Lucifer.

The Church Is Christ's!

My wife and I were in a very important meeting with a woman of God. In the dialogue, a mountain erupted where we had to speak to the situation or it would have taken root. The woman of God started to display insurrection about the mountain and I cautioned her that it was not the way to approach the matter. She responded petulantly with, "You cannot correct me—I'm Paul and you are Timothy." There the spirit of pride reflected in the image of a monster. She considered herself high and lifted up that Timothy could not correct her. That was Lucifer's possession of stronghold.

Our evaluation scale should be *If I'm too high, Lord, bring me down.*

How many Christians today really pattern the meaning of this song, "Lord if I am too high bring me down"? Three out of ten? This song has a lot of spiritual significance to us as leaders. In my early teens, whenever I went to church, I always heard this song sung by prayer mothers mostly at fasting and prayer services. I never understood the meaning of this song so it became boring to me and annoying. But one day I went to another church's early prayer meeting where they had testimony, and again an officer of the church got up and shared her testimony on the same song. He quoted the chorus, *"Let the lower lights be burning."* There and then, the spirit of God convinced me to be more humble. God was saying to me at hand, "Son, you

୫୦୧୫

God can only use us when we are humble and not proud.

୫୦୧୫

need to be more humble for my light to burn within you." I took my rebuke and instantly went home, searching my life in more prayer and fasting.

"Brightly Beams Our Father's Mercy"

Brightly beams our Father's mercy
From His lighthouse evermore;
But to us He gives the keeping
Of the lights along the shore burning
Let your lower light be burning.

(Chorus)
Let the lower lights be burning
Send a gleam across the waves
Some poor fainting, struggling seaman
You may rescue, you may save.

Dark the night of sin has settled
Loud the angry billows roar
Eager eyes are watching, longing
For the light long the shore.

Trim your feeble lamp, my brother,
Some poor sailor, tempest tossed
Trying now to make the harbour
In the darkness may be lost.

"SAFE AND SECURE!"

Jesus the captain of the seaman is coming back to rescue and save us from the roaring waves of the tempest shores; as we eagerly await his coming our lamps must be trim to reach the habour until darkness comes and steal us away.

Be ready, my brother! Be ready!

Sailing in this life without Christ is complete failure

But when you have Jesus as your captain then your anchor will grip the solid rock safe and secure.

Will your anchor hold my friend? Be sure he is the captain of your life today and forever more.

For we have an anchor that keeps the shore safe and secure as the billows roar, fasten to the rock that cannot be moved; our lives need to be fasten to the rock of Jesus Christ.

This rock is Jesus, the only one. This rock is Jesus, be very sure.

❖ Our lives must be anchored in Christ through humility and not by haughtiness of speech.

❖ Our ministry will be darkened when we are self-centered and not conscious of the one who stills the water.

❖ God cannot operate in darkness where strongholds are above the light of God.

❖ Our lamps have to be trimmed to show forth the glory of God in us and through us.

❖ Help comes to those who are of a humble spirit, says the Lord God.

Three

The Distraction of Worship and Beauty: Lucifer

The beauty of worship shifted to the beauty of Lucifer. Psalm 96:6 says, "Honor and majesty are before Him: strength and beauty are in his sanctuary."

> O come, let us worship and bow down: let us kneel before the LORD our maker. For he is our God; and we are the people of his pasture, and the sheep of his hand (Ps. 95:6–7).

> Honor and majesty are before him: strength and beauty are in his sanctuary ... Give unto the Lord the glory due unto his name O worship the Lord in the beauty of holiness (Ps. 96: 6, 8, 9)

This is a powerful illusion that we must all crave to understand through the leading of the Lord. The tact of the *"once anointed cherub"*—Lucifer—is very much real. He was distracted by his own beauty and turned from the presence of God. As a result of this, the root of iniquity was born and named. The infestation of sin begun, this vile serpent injected his venom in man in the Garden of Eden. This in return, he created a spread of deadly viruses that could only be combated with the blood of the Lamb, which had to be a sacrifice, and a consequence in that the first Adam would be last—and the last Adam would be first. Note, when they found out their nudity was caused by sin, they covered themselves with fig leaves. But the omnipotent God first killed a lamb and clothed them from the disgrace. This clothing was very symbolic in the sense that a change of clothing was exchanged in the Garden of Eden. God took on the penalty and gave man the nature of sin. The penalty was a price and the nature was exposition of good and evil. By doing this, our vile nature will be one of uncleanness

to one of holiness by God's design. A token of redemption was seen in the book of Genesis. The root of iniquity was plucked out of the soil, stopping the bearing of its fruits.

Mankind was redeemed with a price so that we can have access again to the throne of God. Although iniquity was formed in heaven's throne room, it was removed and replaced with a courtroom. It is very simple yet profound. In a court chamber, rules are made to govern the day-to-day government of a constituency; not only that, but seats are also won and maintained by the number of votes, good deeds, and legislation. The accuser certainly captures this role in the throne room of God. Lucifer wanted to exterminate the throne room for a courtroom where he could voice his opinions, views, and beliefs against God in anticipation of winning the nomination and the election of the angels. He knows the laws well; he is a legalist. He is a scholar! So he will belittle our capability to incapability of guilt, bringing charges against us. (See Zechariah 3 and 4.) God is the evidence of every case in the *court* and you are the witness to the evidence. You are the evidence to every case in your life. Your greatest battle is won in the courtroom.

ℰↃℭℛ

Judge not and ye shall not be judged.

All judging is done by God.

ℰↃℭℛ

But why dost thou judge thy brother? Or why dost set at naught thy brother? For we shall all stand before the judgment seat of God. So then every one of us shall give account of himself to God (Romans 14: 10, 12).

> Judge not according to the appearance, but judge righteous judgment (John 7:24).

> Judge not, that ye be not judged (Matthew 7:1).

A change of clothing in the Garden of Eden, from figs leaves to animal covering, was necessary. Isaiah 64:6 says "our righteousnesses are like filthy rags." It was filthy in the garden, but it is now washed with the *stain-remover:* the blood of Jesus. All filthiness has become filthless. Divine provision was made, the first shedding of blood pointing to the redeemer (Gen. 3:21; 4:3). Adam and Eve were first consecrated with the blood, ceremonially purged from sin. (See Hebrews, chapter 9 and 10.).

> And almost all things are by the law purged with blood;
> and without shedding of blood is no remission of sin
> (Hebrews 9:22).

The chain of command was given in Zechariah 3:1–5. I am changed to be cleaner. In everything, God has a way out to get you out. Satan was rebuked by God in the courtroom, which was once the throne room. Iniquity can never stay in the presence of God. (See Job 1–2.) The devil can only appear in the presence of God to ask permission, but he cannot stay in God's presence. Why would Satan want to oppose God at the right hand of the throne and not the left hand of the throne? The right hand of the throne symbolizes power and authority. It denotes the right hand of fellowship, friendship, confidence, and fellowship. Those seated at the Father's right hand in Scripture tell and show the relationship, divine extension of supernatural power. There is no left hand of the throne recorded in the Bible. The Bible says God would make our enemy become our footstool at the right of hand.

The devil seeks to gain prominence at the right hand of the throne mainly because he doesn't want to be God's footstool; if he gains access at the right hand of the throne, he will share equality with God the Father and his Son in decision and sovereign protocol. Lucifer always targets the source and not the supply. If he can corrupt and contaminate the source, he will have total dominance over everything. Just like the head in a church, he knows directly where to attack. As the Bible rightly says, if you kill the shepherd then the sheep will be scattered with no sense of direction. God has to protect and guard the right hand of his throne, in other words keep an open eye for any distraction. Standing at the right hand of the throne, you are likely to be given attention and to make an input. This is one of Lucifer's methods. He shows up in the most anointed service trying to bring chaos and confusion to the body of Christ seeking attention. Lucifer's aim was to distract God's attention from listening to Joshua's appeal.

> Then he showed me Joshua the high priest standing before the angel of the LORD, and Satan standing at his right side to accuse him.
>
> The LORD said to Satan, "The LORD rebuke you, Satan! The LORD, who has chosen Jerusalem, rebuke you! Is not this man a burning stick snatched from the fire?"

Now Joshua was dressed in filthy clothes as he stood before the angel.

The angel said to those who were standing before him, "Take off his filthy clothes." Then he said to Joshua, "See, I have taken away your sin, and I will put rich garments on you."

Then I said, "Put a clean turban on his head." So they put a clean turban on his head and clothed him, while the angel of the LORD stood by (Zechariah 3:1–5 NKJV).

God will always have someone beside you to cover and protect you from the snare and noisome pestilence. Don't be afraid to wear your robe, garment, and turban—you are already declared righteous.

Sit thou at my right hand, until I make thine enemies your footstool (Psalm 110:1b).

Special authority and privileges are given at the throne of God. In the book of Psalms, chapter 110, we see some of these special privileges:

- At the right hand of God, you are promoted and exalted to another level (Acts 2:34–36).

- At the right hand of God, you are glorified as the king of glory for returning to the earth and taking the scepter of universal government, and also as the eternal priest, according to the order of Melchizedek.

- At the right hand of God, you are glorified.

- At the right hand of God, superb power and authority are given to you to execute kings in the days of wrath and to judge nations.

- At the right hand of God, your enemies become your footstool.

- At the right hand of God, transfer of garments takes place (Ps. 110:6,5), including love and tenderness (Song 2:6; 8:3).

The Blood of Jesus Christ is the only seal of protection which guarantees Salvation.

- ✋ At the right hand of God, you eat at the king's table and drink of the same brook by the wayside (Ps. 110:7).

- ✋ At the right hand of God, equal rights and privileges are the same in divinity.

- ✋ At the right hand of God, you are crowned with royalty.

- ✋ At the right hand of God, a covenant was made (Zechariah 3).

Four

The Throne Room Becomes A Courtroom

What right does Satan have to officiate and dictate to God? He has no rights, but that's his job—the attorney at law. Joshua standing before the throne, he stands as a priest representing the nation of Israel, which had departed from God. Cleansed and restored. Also, we must note that Joshua represents all of us who draw near by the blood of Jesus. Joshua, being a priest, took on the nature of sin committed by the Israelites in clothes stained with "mire-clay." Each spotted stained represents something: iniquity, wickedness, and sin that separate man from God. Man was in the judgment seat, standing before God with Satan standing at the right hand to oppose him (Joshua). Satan is the attorney of prosecution; God is the judge of forgiveness. He accused the priestly function unfit to carry out sacrifices, but he was rebuked by the Lord. He accused the priest of being unfit to commune; hence, he pleaded his cause before the throne of God. Satan wants the throne room to take the place of courtroom so that he can wrongfully accuse and find all faults to make you feel unworthy.

The time has come for you to lay down the old and be renewed with the new—the robe of royalty.

To receive the promise and provision of God's covenant in Christ for our lives, we must first repent. Our future is determined under this New Covenant of Christ.

"Take away the filthy garments from him (Zachariah 3:4b." "I have removed your iniquity from you … I will clothe you with the robe of righteousness." You are in the presence of the king to look like the king and not to be like the king; therefore, you will be clothed in like manner as the

king. Mephibosheth has spent all his life in Lo-debar because of the guilt of fear and deception by his friend Ziba. He was King Saul's grandson, the father of Jonathan, heir to the throne of his inheritance. Instead of him experiencing royalty, he was experiencing "guilt of filthy rags." God, however, reminded David of the covenant he once made with Jonathan—the blood covenant! David enquired, "Is there any of the house of Saul, that I may show the kindness of God unto him." Yes! A lame boy, Mephibosheth, said Ziba. David, when he heard that he was alive, quickly arose from his throne and summoned his men with a warrant to fetch this young man. Mephibosheth had not claimed his inheritance as royalty. He was the descendant of the anointed one of Israel, yet he exchanged the truth of his position for the lie of his circumstances. The devil, the father of lies, only speaks dishonesty. He had believed that his present had to be chained to past failures and tragedies.

The anointing on his life had not been originally earned by his father, Jonathan, or his grandfather, Saul, but was imparted through their act of faithfulness to God. Anointing to royalty can never be earned; it is imparted as a gift. And what has been given can never be removed by any circumstance or person other than the One who gave the anointing. Not even King David could harm this descendant who was specially anointed by God. Years before, when presented with the opportunity to kill King Saul, he confessed, "*I will not put my hand on the lord's King, Saul; he is the Lord's anointed servant*" *(1 Sam. 24:10)*.

Anointing is an inheritance promise to the body of Christ before the creation of heaven and earth. The point here is that the anointing is not just for us to enjoy. It is given to all believers to meet the needs of those around them. In like manner, the anointing on King David's life was to seek out Mephibosheth in relation to making the necessary provisions to promote him to his father's inheritance. The anointing on David's life was to break the stronghold on his life so that he could experience the royalty of God. The anointing of God's spirit is upon you to preach good news in unpleasant circumstances, in state of depression, in the prison cell, and in the enemy's camp; to bind up the brokenhearted; and to proclaim liberty to the captives.

Isaiah testifies to the good news of salvation in 61:1–3:

> The Spirit of the Lord God is upon me, because he has anointed Me to preach good tidings to the poor; he has

sent me to heal the brokenhearted, to proclaim liberty to the captives, and the opening of prison to those who are bound.

To proclaim the acceptable year of the LORD, and the day of vengeance of our God; to comfort all who mourn;

To console those who mourn in Zion, to give beauty for ashes, the oil of joy for mourning, the garment of praise for the spirit of heaviness; that they may be called trees of righteousness, the planting of the Lord, that He may be glorified.

When we stand in the throne room of God, we are his anointed servants; there the devil cannot touch us without permission from God. He can't derailed, defile, and destroy our position in Christ; he is not the producer or manufacturer of such anointing on your life.

Out of Lo-debar rode the king's quest; the very name of the place means "not a pasture;" a dwelling place of poverty, dryness, and desolation. It was bewildered with wilderness, desert, and barren land of no sowing and harvesting. In Lo-debar—nothing was there! Nothing worthwhile was there.

From Nothing to Something!

In the king's palace you will be clothed with new robes of white linen and sandals crafted from expensive leather. In the king's palace, you will be different. One prerequisite assurance is you will be made clean and whole. Getting a bath in the king's palace is the best thing that can ever happen in times of frustration. May I say he was the man for the hour, minute, and the day because he was the ultimate reasons for all the gathering and celebration at the king's palace? Your purpose in getting a bath in the king's palace simply portrays promotion from better to best. From great to greater to greatest and from big to bigger to biggest was going to be handed down to him at the king's request. The transforming stage form glory to glory will happen bearing the image of the king. This is your day, my friend, to be transformed from glory to glorious. Your bath and robe are symbolic to the throne. One must be washed by the blood of the Lamb to reign on the throne and one must be fully clothed in righteousness to teach and bear the mark of Christ. Clean yourself up! Put on the robe and sandals. Prepare to

dine with the king. The best of the best will be there. The soiled clothing from his body, the odor from his flesh, and the malnourished appetite are about to be wiped away. The time has come to experience royalty.

THE MANTLE IS UPON YOU

Spoken declarations activate God's power for your purpose

Say this every morning

Declare your morning and it shall be established says the Lord

Job 22:28

You will declare a thing, and it will be established for you

So light will shine on your path.

I therefore declare that the mantle of Elijah is right now upon you to exploit extensively; the gifts that are presently on you to expose the deeds of principalities and strongholds that are seemingly trying to surround that which God revealed to you. Divine intimacy with supernatural revelatory ingredients is upon your life to commune with God in the entire prayer arena ministry as you expound the word and deliver God's people. This mantle, says the spirit of the most high God, is uniquely powerful with extra authority to bind and loosen the bonds of depression, alcoholism, prostitution, and setting the captives free. Receive ye this prayer-invested mantle, ordained particularly for you.

The anointing favor of the past will sought you out.

The anointing favor of God will go ahead and make the path possible.

The anointing favor will reveal who you are; one of the king's ambassadors.

Our provision and promise have been laid up as an inheritance, if we only can see it and claim it.

Purple is the color of royalty, making Mephibosheth a royal priest in the sight of King David. You are not just around an ordinary table

but around the king's table. The thing is, only special people are invited to the head table to dine with the king. Only special orders are made. The bliss of joy that filled the room was so overflowing. The beautiful worship songs, the harmony of collection of musicians has consoled the wounded man to worship in the presence of the king. So caught up in the awesome surroundings, he had almost forgotten to look up toward the head of the table. It was King David! The delighted greetings and welcome that he made to their special quest that evening created an atmosphere of tears and joy. When you are in the king's presence, there is no need to be afraid.

Something superb happened to Mephibosheth when he was at the table; the fears of his past were no more remembered. No one displays any discrepancy where he was concerned; as a matter of fact, he was in the presence of the king, and therefore there was no room for such entertainment. The room was filled with the glory of heaven. Another thing worthwhile mentioning is he forgot to look up and smile at the head table, mainly because of the presence he felt flowing and transferring one to the other. This means that when you are in the presence of God, you are so deeply peaceful that you don't even want to glance at others. So it must be as children of God, rather than being spectators; let us bow and worship before the Lord our maker.

ഇൗരു

A promised relationship is a promise of hope that gets you beyond the past to a new life.

ഇൗരു

Oh come, let us worship and bow down; let us kneel before the Lord our maker. For he is our God, and we are the people of his pasture, and the sheep of his hand (Psalm 95:6–7).

In his presence, there is fullness of joy and at his right hand pleasures forever more.

> Enter in his gates with thanksgiving and into his courts
> with praise, be thankful unto him and bless his name for
> the Lord is good (Psalm 100:4).

The story of the prodigal son was another touching experience that brought many souls to Christ. The prodigal boy's life was ruined when he walked out of the presence of his father's livelihood. He was never the same; instead of prospering, he was getting poorer and poorer. Instead of royal apparel, he was wearing rotten clothing. All this happened

because he disobeyed his father's advice and chose otherwise. Eating at the king's table became eating out of the pigpen. He was conflicted with the thought of returning home as demons tormented him into thinking that his father would not forgive him for his foolish decision. He was broken in heart with nothing left but to return home. The Bible says, "A broken and contrite spirit will I not despise." In his entire dilemma, he had a relationship with his father. A promised relationship that would earn him back his portion and destiny with his father. All he had was a promised relationship; I will not leave you nor forsake you. I will come to you comfortless, with or without clothing. I will not leave you—break not the promise.

This promise was enough to cross the bridge of the past to the promised land of a new life. He had once run away from the promise, hoping to find a new life. Now he knew (acknowledged) in the depth of his soul that the only life he would ever depend on was a father's promise (forgiveness) to start over again.

Satan will put stumbling blocks in our path to rob us of our inheritance, but all we have to do is remember the promise of the father. The *what if* attitudes always keep us living on fear and not by faith. *What if* is a distraction of vision and promise. It creates roundabout turns in our lives, from possibilities to problems, positive to negative, and from hope to despair. The devil will stop you with the simple *its*. Go home in the name of Jesus. I speak to every one of you that is reading this book. You have turned away from the promise of your father all because of your foolish decisions, but you can return home and conquer every guilt, fear, despair, and *what if* in your life, ministry, business, and relationship. I know that I am speaking to someone right now who thinks that all is lost. Yes, you did sin, but he will forgive you also because he is at the door looking out for you to return home.

Now is the time to face your greatest fear. Now is the time to complete the assignment given to you months ago. Now is the time to face your father and repent. What a beautiful scenery God has provided for us today. It is joy to return home to be with your family. The boy faced the consequence of the past by returning home and reaped his harvest that awaited him. He was welcomed home! Clothed anew and given his promised royalty. God and the angels in heaven rejoice over one soul that comes to him. There was a great celebration for the miraculous reunion of his son.

The parallel of this text is that there was a change of clothing from filthiness to righteousness. God wants to give us what belongs to us. You can lose everything you have, but you can never lose anything God has. You are not serving the Lord; he is serving you. Go home for the change of garment—the banquet is prepared for you.

A father's love will never change. His promise will not return unto him void, but it shall accomplish the covenant promised concerning you and me.

The message here in each *periscope* is the change of garment. This meant something necessary. The removal of iniquity was divine so as to be partaker and joined-heir in the fellowship and communing at the banquet room. This is more than a temporary change of garment; it is the permanent removal of "the iniquity" that has controlled us since that moment in the garden thousands of years ago. God had to erase or clean out our old wardrobe and present us with a new one. *Perfect love exposes the deeds of the flesh, conquering the spirit of fear, and therefore brings restoration and healing to the wounded.* Our filthiness is removed to the trash bin, and we stand before God restored. A new set of clothing, says the Lord, will never bring back old memories but will encouraged happiness, joy, newness, appreciation, and peace of restoration in the home. It will put a smile on your face. We were born and shaped in iniquity, but now we are clothed with righteousness from the disgrace of sin—glory!

When we stand in the court, we stand in nakedness in guilt and shame. However, God orders his angels to place priestly crowns on our heads. He then begins the process of the renewal of our minds and thoughts so that we will have the mind of Christ to live holy in this new state of glory. The process of renewal also focused our attention on God and not self-exaltation. After the process of renewal comes the celebration: royalty—where we all dressed in our priestly apparel for one common purpose, which is to celebrate and praise the creator of heaven and earth. The Bible says we are given the garment of praise for the garment of heaviness. The priestly robe calls for worship. We are all clothed in heaven's court to worship and celebrate in his glory. Note in the book of Zechariah that God

Perfect love exposes the deeds of the flesh, conquering the spirit of fear, and therefore brings restoration and healing to the wounded.

did the clothing and not his angels. From Genesis, we see this covering was applied, meaning it is God who makes the final decision. It is not by our fame and celibacy of significance that we are clothed in his presence; it is simply because of his love and promise: I go to prepare a place for you and where I am you will be there too. (See John 1.)

The celebration in heaven's court signifies that we are free from law and bound to grace. We are emancipated to the throne as long as we live. Each one of us is a priest. We no longer walk in the crookedness of the old path; we are no more slaves to sin because the curse is removed far as the north from the east. We are now children of the light of God. When seated in the presence of the king, we are as royal priesthood, peculiar and holy people representing his kingly attributes. We are shaped in his image and wonderfully clothed in all likeness. The guilt of fears are all removed and replaced with the faith of God. The war we fight is won at the throne of God, the initial place where iniquity had begun. Our victory is by the grace of God that is keeping us from falling. The enemy's strategies were to rob us of our fellowship and worship with God, but, regardless of his objective, we have now seen how the enemy's strategies work. They gear us up to stand against the wiles of the devil by putting on the complete armor of God. It is important to note that, once again, not all sins are the result of direct satanic involvement. Some of it is the influence of our iniquitous old nature, which is innately prone to sin. To ascribe all sin to Satan is to give him glory and honor.

Five

Living before the Throne of Worship

Living before the throne gives us access to commune with the father in the spirit; in the spirit of thanksgiving, praise, and worship. It creates an environment of peace, joy, and thanksgiving. All conditions are met and satisfied at the throne of God. It moves us beyond the ordinary to the extraordinary level of greater experience. We are thus living in the spirit and not the flesh. We cannot communicate in the flesh before the throne because there will be distraction of worship, unstable mind, and double mindedness, and the mystery of iniquity will develop into pride. The throne is God's place of authority and power, a place of worship and reverence. Thus when we go before the throne of God, the act of devotion must always be climaxed. The good thing, though, is we are free from all ills of life to be loyal to God, to worship without interruption. We are restored to that place of sweet communion that Lucifer once enjoyed, and we are restored to that place of fellowship that Adam enjoyed with God at first.

- Living before the throne of God, we become the "almond tree," blossoming and bearing fruit in the middle of winter. (See Jer. 1:11.) Trees do not bear fruit in winter, but when you are at the throne of God in worship, anything can happen. The spirit of worship causes things to happen and produce in our lives, such as fellowship and reconciliation with God, deliverance from burdens and depression, and give the peace of God.

- Living before the throne of worship, you meet face to face with God. You don't have his promise but his presence to assure and comfort you.

- Living before the throne of worship, we discover the abundance of life in Christ as we yield wholly to his will and desire to fulfill his purpose in every deed and word.

- Living before the throne of worship, we experience the beauty of holiness (Ps. 29:2) and live a more consecrated life.

The Threefold Anointing before the Throne

(Thanksgiving, Praise, and Worship)

To actually go before the throne of God, there are prerequisite conditions. The word of God sanctioning this solemn vow of worship in the book of Psalms, which was instrumentally written by King David at the point of divine intimacy with God and other great men of the Bible. Entering into the courts of worship, David rightly says that "we should enter into his gates with thanksgiving and into his courts with praise." In the inner court, only the spirit of worship gets you behind the veil, the throne of God. Very powerful and yet indeed profound to the foreknowledge of humanity of excellence, the revelation of God behind the veil compared to the gate and courts experience. In worship, divine revelation is handed down to us as an act of appreciation.

ଚ**)**ଔ

Thanksgiving and praise can only take you to another level, but worship takes you to greatest levels in God. In worship, you experience the triune presence.

ଚ**)**ଔ

The Power of Thanksgiving

Thanksgiving as we know is offering our gratitude to God for his faithfulness toward us in that they are new every morning, according to Lamentation chapter 3.

Great is thy faithfulness, morning by morning new mercies we have seen and all that we needed his hands provided.

This I recall to my mind. Therefore have I hope. It is of the Lord's mercies that we are not consumed because his

compassions fail not. They are new every morning: great is thy faithfulness (Lamentation 3:21–23.).

On this note, the expression of thankfulness is made in supplication to God at all times; the Bible says to do so, *"always giving thanks in the name of our Lord Jesus Christ to God, even the Father"* (Eph. 5:20).

The anointing in thanksgiving is to prepare our physical bodies as an emblem before the Lord. With our bodies we come into the outer court with thanksgiving, thus we become the temple of the Holy Spirit. The first gate to the outer court is the gate of thanksgiving. In celebration of the tabernacle feast and victories, Israel would sing psalms of thanksgivings, one of which is, "Enter into his gates with thanksgiving, and into his courts with praise." (See Ps. 100:4.) It was the will of God to give thanks as even today, "In everything give thanks: for this is God's will for you in Christ Jesus" (1 Thess. 5:18).

ഇ)ഗ

God's will for our lives starts at the gate of thanksgiving. In thanksgiving, your will is hidden in Christ, meaning he is working everything out for your good.

ഇ)ഗ

God's will for our lives starts at the gate of thanksgiving. In thanksgiving, your will is hidden in Christ, meaning he is working everything out for your good.

The outside of the tabernacle was always illuminated by natural light, which means that anyone can do it. Thanksgiving is natural, you can see it with your literal eyes, but with worship it takes the spiritual eyes to see the glory of God among his people. Thanksgiving is occasional for some, but worship is living, meaning everything about you should denote worship. Thanksgiving is more of a choir practice where you read and rehearse stage by stage. It is natural to do that, but to worship it requires the spirit.

Thanksgiving transcends the peace of God, which guards our minds from the worries and unlimited pressure of the world.

ഇ)ഗ

Thanksgiving transcends the peace of God, which guards our minds from the worries and pressure of the world.

Expressions of Thanksgiving

- This can be seen when we clap our hands and play the instruments.

- This can be seen when we dance before the Lord. David danced when the ark was restored to Israel (2 Sam. 6:14).

ༀ

Thanks cremate the enemy because you are entering in his gates with thanksgiving and praise.

ༀ

The reason for referring to the anointing as important in thanksgiving is simple: "our bodies are the temple of the Holy Ghost." Therefore, when we express thanks to God, we are saying to Satan and the world that we are not bound in chains, but instead we are free from the slave of sin. Thus we can demand and command things to happen in the natural, such as our healing, our deliverance, our jobs, provisions in our lives, and marriages. Our bodily expressions in thanksgiving reflect the attributes of God because we have his glory.

Worship Begins with Thanksgiving

Giving thanks to God also means giving thanks to God for what he has done in our lives. Thanksgiving is also counting our blessing for what God has done. The songwriter catches the vision and penned it.

Count Your Blessing

When upon life's billows you are tempest tossed,
When you are discouraged, thinking all is lost.
Count your many blessings, name them one by one
And it will surprise you what the Lord hath done.

Count your blessings, name them one by one,
Count your blessings, see what God hath done!
Count your blessings, name them one by one,
And it will surprise you what the Lord hath done.

Are you ever burdened with a load of care?
Does the cross seem heavy, you are called to bear?
Count your many blessings, every doubt will fly,
And you will keep singing as the days go by.

When you look at others with their lands and gold,
Think that Christ has promised you His wealth untold;
Count your many blessings. Wealth can never buy
Your reward in heaven, nor your home on high.

So, amid the conflict whether great or small,
Do not be disheartened, God is over all;
Count your many blessings, angels will attend,
Help and comfort give you to your journey's end.

Revelation is given
when we praise
God in his beauty
and holiness.

ℰℭℬ

We must have a mode of thanksgiving at the gate before we can experience the throne. The Israelites rehearsed many times before they entered the gate so be prepared at all times.

Our expectation of God to work in favor of us must begin with thanks on our lips (Hebrews 13:15). Thanks cremate the enemy because you are entering in his gates with thanksgiving and praise.

The Power of Praise

The inner court of praise is where our soul cries out to God in all things. This is where we draw nearer with a true heart as we proceed to enter the inner court of holies. This is also where our conscience must be first washed with the blood of the lamb so that our motives will be pure and holy before the creator. (See Hebrews 6:22.)

The contrast of the outer court to the inner is seen by the nature of light produced at each stage. The outer court has physical light while in the inner court only golden candlesticks can be used, which represents the word of God. Therefore, as we enter in his court with praise, we are to take with us the word of God, which is described as the light and lamp of God to our feet. (See Psalm 119:105.)

Revelation is given when we praise God in his beauty and holiness. Praise releases the supernatural into the natural. The word of God commands us to praise God in everything as seen in Psalms 100 and 150. The same principle is given also in Hebrews 13:15: "When the praises go up then the blessing will come down on us." The word of God tells us "to

offer unto the sacrifice of praise continually, that is the fruit of our lips giving thanks to his name" (Hebrews 13:15). Our lips must always have praise to give to God at all times. When we go to church, we must carry our praise to receive from his throne of grace. (See Psalm 34.)

Praising God is an everyday lifestyle that should be more prominent among the body of Christians. Too often we become so lukewarm in our worship and praise to God that even our sacrifices and sweet-smelling favor don't minister to the unsaved much less the throne of heaven.

The Bible says that God inhabits our praises mainly because he dwells among worshippers in heaven.

Miracles Are Transcended through the Spirit of Praising God

Paul and Silas sang praises to God at midnight while in jail and were delivered by a sudden earthquake that opened the prison doors and broke the chains on their feet. Praise can bring you out safe and sound without any wounds when it is offered and generated from a true heart with meaningful value to God. (See Acts 16:26–34.)

Praising God can do the impossible only if you believe. Paul and Silas were free in spirit yet bound physically, but they sang praises to God. If your spirit is free to praise God, then those around you will grumble at the shout of *praise*. Praise releases every depression and oppression that the enemy has placed on you for years.

&)CR

In the Holy of Holies is where the worship is attributed to God.

&)CR

The most amazing miracle that took place that night was that the prison was converted by the power of God that was manifested in praise. A lot of church folks believe that we don't have to praise God to experience more of him, or we don't have to shout, but if we should do a thorough study on praise, you will understand that most of the battles in the Bible were won by praising God.

Having the light of God in the inner court means having the word of God to comfort and console you as you travel along the journey of faith to the promise of hope.

Praise Is the Key to Open the Door of Worship: In the Holy of Holies

The holy of holies is the meeting place with God. This is where all things are possible with Him regardless of how difficult it looks. This is where the fullness of his presence is revealed and released to those who thirst and hunger for his righteousness (Matthew 5:6).

The Power of Worship

We are called to worship with our spirit to God in heavenly places at all times. Worship is the source through which the Holy Spirit operates and manifests the gifts of the Spirit in diverse ways. It is the channel to know the power of God. Through worship, the mind of God is known to us and is touched by the expression of the saints in complete adoration.

ഐറ്റ

The order of worship is through our consecration and sanctification unto God.

ഐറ്റ

The presence of the holiness of God is always revealed in this area, which further defines the true essence of worship as we commune with God as friend with friend. The order of worship is through our consecration and sanctification unto God.

We must cultivate the practice of living in the glory of God to reflect the priestly act of worship offered up to God. God is not hard to find; our desire should be foremost to seek more of Him. When we do this, the incense of worship (presence) fills our hearts and saturates the atmosphere with greater revelation and blessings.

Our motives must be pure when we are approaching the throne of worship. We don't need a building to worship God. Worship is the indwelling of the Holy Spirit.

As mentioned before, this is where God meets with man and man with God. The Holies of Holies resides on the inside of you since the day you accepted Christ; your life has become a sanctuary of thanksgiving, praise, and worship unto God.

ഐറ്റ

Worship is the source through which the Holy Spirit operates and manifests the gifts of the Spirit in diverse ways.

The psalmist says, "Worship the Lord in the beauty of holiness" (Ps. 29:2).

Worship generates from within. It is like a running river with inner joy that comforts the souls of men. Our lives must be so dedicated to God that our worship reflects his holiness unto the world when we minister.

Seven

God's Servant, the Branch

Now that we are restored to God through Jesus Christ, we don't have to work in the devil's shop of lies, sedition, tactics, and manipulation anymore.

We are now connected to the branch of the vine according to John 15. This branch would expose and reveal every hidden agenda of the devil. Now every branch is connected to a source that it gets its nutrients from. Without this connection, the branch would wither, later die, and be cut off completely. In science, we learn that excessive limbs on a branch can cause irregular functions and the transfer of enzymes, which will result in the deficiency of energy and substance in the plant. So the solution will be to cut off the unnecessary branches for proper flow of plant intake for energy. This branch, however, is the Lord Jesus. He never lacks plant nutrients, growth, or substance.

What makes the branch beautiful is the supply from the vine, which is God.

How can the branch be beautiful and glorious (Isa. 4:2)? The branch replaced the bitterness of our sin so that we could experience the sweetness of salvation. (See Genesis 15:22–27.) A leaf or branch has the same taste as the vine or root.

What Makes the Branch Beautiful Is the
Supply from the Vine, Which Is God

Every production of tea that we love to drink is from its source, the root. Zechariah told us that it is by the "Branch": "I will bring forth

my servant the Branch" (Zechariah 3:8). The branch is the savior, who was cast into the bitter waters of our iniquity to sweeten us.

The tact of Lucifer will not end until his final doom in the lake of fire. The children of Israel under the leadership of Moses in the wilderness came to the river of Mara, which means "bitterness." Now it is important for us to know that a running stream can never be bitter, except if it has sediments from dead animals, debris, and other elements, or if toxins and waste materials are thrown and left in the water. What could have caused this water to be bitter? Studies have shown that chemicals found in the water when formulated were from the sulphate of lime, magnesium, chloride, etc., and could be the logical conclusion as to why the water was acidic.

Where there is a habit of sin in a believer's life, expect to find demonic activities in that area.

The Bible gives us a highlight of what took place in heaven with God and Lucifer. (See Ezekiah 28 and Isaiah 14.) He was made perfect with wisdom and power until iniquity was found in him.

Thou was perfect in all thy ways from the time thou was created, till iniquity was found in thee (Ezekiel 28: 15).

He was kicked out of heaven as a result of the nature of iniquity. Iniquity in my own opinion is the corruption of good to bad with the motive of perversity and crookedness. Other definitions are character of action having self-righteous attitudes that are like filthy rags; the expression of guilt. Filthy rags are dirty and odorous. There was no statement proving a spiritual, symbolic, or typical meaning revealed by in-depth studies. But on the other hand, I believe something has transpired with a revelatory meaning. The Bible says the children murmured. In other words, they complained against Moses. From a spiritual background of studies of demons, murmuring is a stronghold of thoughts generated from a source (in the mind) before it is manifested. It is definitely a spirit rooted in demonology.

The Israelites were known for their habitual murmuring. As Francis Frangipane rightly puts it, "Where there is a habit of sin in a believer's life, expect to find demonic activities in that area." This habit of murmuring becomes a dwelling place for a spirit to infest and manifest itself. One of the devil's jobs is to elude your mind with the spirit of complaining, to get

you frustrated and confused so that he can deceive us with vain thinking. The weapons of our warfare are not carnal but mighty in God through the pulling down of strongholds that seek to exalt themselves against the powers of God, casting down vain imaginations of conceit.

The battleground of warfare is the mind. Satan targets the mind to gain control. The Israelites did not drink the water because they realized it was not drinkable; the water was bitter. (My personal suppositional thoughts; "iniquity" was the bitterness) and needed to be sweetened with the "blood of Jesus." Moses put a tree (not known) in the water and it became sweet. Bitterness (sin) is from the devil and sweetness (salvation) is from Jesus. The stain of iniquity was removed from the water and replaced with pureness. In this case, Christ was a stronger agent of reaction chemically and spiritually. Bitterness is one of the longest and hardest tastes to get rid of when swallowed. It sometimes last for days. For example, when killing chickens and other animals, if the pancreatic bile (bitter bile) bursts in the process, it could cause the meat to taste different.

On the cross at Calvary, we have seen also where they gave Jesus vinegar instead of water. Jesus drank the bitter cup for you and me; it was the plan of the devil for the children of Israel to drink the bitter water so as not to fulfill the purpose of the promised redeemer. The plan of salvation would have cancelled then and there, but thanks be to *The Branch,* the true vine that was available to suffer, take up the cross, and drink the bitter cup so to reconcile man to God.

> I speak this prophetically in the lives of every born-again believer. You were created for a purpose in the image of God and that purpose was enveloped or created with the spirit of God, to be anointed with the Holy Spirit to set lives on fire for God, to display his tangible anointing to lukewarm churches that comply with the lies of the devil's signs and wonders. Yes, you are a double-anointed cherub for this end time to bring hope to every skeptic who is driven by doubt; you need to witness a Messiah who is full of wonders and a wonder-worker! People need to witness, through us, that He is indeed risen, just as He said, and his anointing is working on the inside of us to show them our Savior.

You are an anointed cherub peculiarly called out and set aside as a remnant, living in the supernatural realm of the double portion. Let me tell you this: the devil has lost that place of authority, supremacy, and inheritance. This worship anointing, "bright like the morning star," that fills the room when he exalted in attributes to the Lord is now handed down to you. The Bible says that "all powers are given unto you." You are now the light (the morning star) and salt representing God in all aspects of his kingdom. The Bible says that you are the light of the world. Therefore you have been given the power of authority, power to heal, power to worship, and power of authority. Use the power; it's yours. The Lord will touch you and you will be changed. When you realize you can have this double portion, you will never be the same again. You will refuse the mundane and the mediocre.

You will walk on earth as a spirit man led and anointed by the spirit of God. And there will be proof, signs, and wonders to attest to the anointing of the Holy Spirit upon your life."

As a part of the church of the first-born, there is a double portion waiting for you and me. The Bible promises, "And this is the confidence that we have in him, that, if we ask any thing according to his will, he hears us: and if we know that he hears us, whatsoever we ask, we know that we have the petition that we desire of him" (1 John 5:14–15). The double portion will start to manifest in our life. All we need to do is receive it. Make no mistake: there will be mountains to climb and valleys to cross, but there is a double portion of the anointing residing on the inside of us to take us all the way to victory.

The devil wants us to think that he has power, and he does, but his power is tied up in heaven's legal system. He can't use it any way he would like to because he's held in check by God, who has our interests in mind. At the bank, the banker has your savings and not you. For you to get that money, you have to sign the notes with your signature before you can get the money. The devil has to confer with almighty God before he can touch you. I got this one from Bishop George G. Bloomer: "A will!" I could die tomorrow, leaving all my money to the benefactors of my will, but if other

members of my family wanted to, they could contest my will in favor of their own interests. This would then lock up my willed money until my rightful heirs got a lawyer and straightened things out.

Similarly, God has willed salvation and blessings to those who receive his saving grace (saving account). But Satan has contested the will of God. As a result, you have to petition your advocate, Jesus, to take him on. But Jesus has never lost a case! He will seal your court papers with a drop of his sacrificed blood and the case will be closed. The Bible speaks of being joint-heirs with Christ. Whatever belongs to Christ is automatically handed down to us. So with the anointing of God, we are inheriting from the inheritance—the source, God!

You are what you were created for; to worship God in the spirit. You take the place of the devil—yes! You are his mouthpiece. The devil cannot worship in the spirit of God but he won't last. Because he is not genuine anymore; he is only a counterfeit. He can't stay in the presence of the almighty. You and I are privileged to stay and worship in the presence of God. As a matter of fact, we have access to the throne of God through his son, Jesus Christ, who is our mediator and intercessor. We have the rights to enter into his gate with thanksgiving and into his court with praise. He was created to usher in the praise and glory to God. He was a worshiper because to hear the voice of God he had to worship. What qualifies a believer in the presence of God is worship. Only worshipers enter the holy of holies—where God communes with us. Lucifer has had to be at his apex of worship when he and the angels came before God. It is through worship that they would receive revelation and even instruction from the triune God. Revelation only comes through worship and not from praise. The more they worshiped, the more God would reveal and commune with Lucifer, but as soon as worship stops the same would also cease. The Bible says that God is touched by the feelings of our infirmities. Such infirmities come from worshiping God in the spirit of holiness. Satan never visited God in the inner court. There is no record of such. He always worships in the holy of holies.

ೲ

Satan never visited God in the inner court. There is no record of such. He always worships in the holy of holies.

ೲ

Eight

Anointed: Be Careful Who Gets The Glory

H is deceptive motive was "to be like God" (Isaiah 14). His mission shifted from reflecting the glory of God in worship to seeking glory for himself. This one who had stood at the place of ultimate influence at the throne of God perverted his position, lusting after the adoration that filled his heart. He took his eyes off the creator and sought his own glory. This was a result of pride as mentioned in chapter 2. The anointing can only operate in a vessel of submission and not in a vessel of pride. The anointing is to serve others through the channel of giving glory and honor to God. Pride is the root of evil, created by the devil to derail our attention from God through his tactics and devices. The anointing destroys yokes but also energizes our adrenaline hormone, which causes our emotions to act up controllable and uncontrollable at times. As the anointing increases on our lives, a greater tendency for closer companionship, whether single or married, could arise. Our hormones are not saved at all. Many mighty preachers have fallen in this web of the enemy when they are at the point of being too vulnerable after finished ministering. The word of God says, "You must not trust your own (self) but rely completely on God for courage when problem arises."

ৰ০জ্ঞ

Not everyone is anointed to go in the holy of holies. Note you can go in the holy court, but only designated persons who are living a holy life, totally God fearing and blameless.

ৰ০জ্ঞ

This may sound very bizarre on the other side of the coin; many mighty preachers are caught in the "barber shop of Delilah." We have to be on double watch as ministers or leaders not to be opened to pride, simply

because we are only stewards and not owners of the ministry to which God has called us.

∞)(∞

Not everyone is anointed to go in the holy of holies. Note you can go in the holy court, but only designated persons who are living a holy life, and are totally God-fearing and blameless, are required to go in the holy of holies.

∞)(∞

He who exalts himself shall be abased and he that is humble himself shall be exalted—"anointed." Can this be true or real? The temple of God from the Old Testament era is the dwelling place of God; this place is saturated with the Shekinah glory of God. It is where he lived and revealed his presence to the children of Israel. The pulpit or Ark of the Covenant signifies the presence of God—the holy of holies—in that it is a place where only anointed vessels should stand to declare the word of God, but this not so any more. The focus of the pulpit has changed from God-fearing to man-fearing. The anointed is no more seen in the pulpit; the spirit of pride has propagated the pulpit.

It is logically evident when the anointing is in operation from that of self. We must protect the pulpit from the wiles of the devil—the spirit of pride. The devil's motive is to pollute the temple of God through ministers in sheep clothing. Why when a pastor is in the pulpit he behaves differently from normal duties? For the reason he stands in the seat of authority representing God. Now his focus has to be to intact with God at all times. Adam, for example, was placed in the position of leadership to govern the daily activities in the garden. The devil is very cunning but the anointing will reveal his deeds.

Not everyone is anointed to go in the holy of holies. Note you can go in the holy court, but only designated persons who are living a holy life, and are totally God-fearing and blameless, are required to go in the holy of holies.

Remember who anoints and calls: God, not man! You are anointed to rebuke and not to rebel. Any authority based on sedition or insurrection is rebellion, according to Rick Godwin, author of *Training for Reigning.* All rebellion is rooted in witchcraft from the devil—period. (See 1 Samuel 15:23.)

Nine

The Anointing Is to Serve

Ambition to Serve or Ambition to Position

That which comes from above—God!—is good, perfect (James 1:17) and pure (3:17). But its counterfeit is devilish. Ambition for the anointing is of paramount importance; the Bible clearly refers to such desire: "As the deer panteth after the water brooks so panteth my soul after thee, the living God" (Psalm 42:1). Therefore having a desire for more of God's double portion inheritance is a good one and biblical. Ambition is defined as "the eager desire to achieve something." Ambition is a key factor in effective leadership roles. Selfish ambition, on the other hand, utilizes the arm of the flesh for the purposes of self-promotion, fame, or power. The word *ambition* comes from the French word *ambile,* which means "to go around for votes." A person with this type of attributes is driven to achieve fame, power, and self-promotion from those who he or she associates with.

ℰℒ

The anointing is to serve in the marketplaces.

ℰℒ

The process in becoming a democratic leader of any country is by voting through the constitution by having an election. The majority, as we know, will vote for people who are administratively and academically educated with the vision and mission to make the country a better place. They earned their points by going around persuasively winning the hearts of the people by making promises. Mark you, not all these promises will be fulfilled, but it is a psychological strategy to gain nomination. Upon doing this, they are left in a balance of failure or success. Their failure or success is in the hands of the people. The anointing is not achieved; it is not cheap; it is given or received by laying aside every besetting sin. The

anointing is not given for us to enjoy. It is given to every believer to meet the needs of those around himself or herself.

The prophet Isaiah described the anointing in this way:

> And it shall come to pass in that day, that his burden shall be taken away from off thy shoulder, and his yoke off thy neck, and the yoke shall be destroyed because of the anointing (Isaiah 10:27).

The anointing is not for promotion, self-exhortation. The anointing is not to influence; rather one of its purposes is to convict of sins and wrongdoings.

The Bible tells us that God promotes us. Watch that leader, per se, that goes around with the *ambile* influence or spirit; his intent clearly defines his motive and ambition to position and not servant hood. Promotion begins with servant hood. Jesus said, "Whoever desires to become great among you, let him be your servant" (Matt. 20:26). The apostle Paul warned against vain conceit in Philippians 2:3. It does not matter how much influence you have attained through degrees of higher achievements in life; if God is not the head of your status in your endeavor, you will be abased sooner or later. Ambition can easily transform into pride-ambition. You see yourself higher and more qualified than the rest of your members. Even if you are qualified secularly and ordained into an office, the qualifications does not give you precedent over the person. Our promotions and qualifications come from being a servant, not a master. Therefore, our involvement in the body of Christ must not take on ownership of the ministry. We are only vessels of clay in the potter's hand, serving in the capacity of stewardship. Self-motives can easily be seen in the pulpit and pew. *Who is greater than whom?* This is the trap into which Lucifer fell. *We must not have any idols in the house of God other than the creator, Christ Jesus.*

ഇറ

We must not have any idols in the house of God other than the creator, Christ Jesus.

ഇറ

The ministry of Lucifer's background is defined in Ezekiel 28. It seems that Lucifer was an angel at the time God created the Garden of Eden, and it seems that the interim of his fall was somewhere between the creation

of the earth and the deception of Adam and Eve. Lucifer at some point was cast out of the parliament of heaven. He was in the garden, according to the record of Ezekiel, probably working, watching the creative work of his master. One thing we know though is that "he was walking up and down in the midst of the stone." This goes to tell us that he was very much acquainted with the Garden of Eden. It was his home then so to speak. If he was also walking up and down in the Garden of Eden, we could isogetically say he was a guardian cherub. The probability is strong by virtue of exegesis that Lucifer may have assisted God with the creation of the Garden of Eden.

Why Take Offense—Correct Information, Not Imagination

How often do we take offense from others? How often do we first get our facts straight? We begin to get offensive by our perception. Feelings are not reality. Basing our feelings and reaction on supposition and assumption is not facts. We only perceive injury by our own imagination. Perceiving imagination without correct information builds up strives in the heart and make matters worse. You are just making a fool of yourself and adding fuel to fire.

The word *information* is defined as "having the facts straight before carrying out the procedure; know before you tell; being knowledgeable; arranging before giving out." On the other hand, imagination is perception, using your creative ideas to come about a thing; a designer, a thinker. Having the wrong conception about a person can ruin your life forever. This was the case study of Lucifer. He realizes that man was going to be created and made in God's image. He was nervous, I believe. How could this be? God is going to have a new creation. A best buddy is sometimes jealous of having a second best friend around you. That person will feel left out and ignored based on his or her perception of thoughts. The Bible says we must cast down every imagination that seeks to exalt itself against the knowledge of God. Lucifer had a wrong concept of God's plan by allowing vain thoughts to hover over him. Feeling inadequacy is not from God. Years of living has nothing to do with your reward—it is your years of service and the life you live. I rather say the life of the service given to God. Your labor is not in vain.

Imaginative thoughts are always words like *I always thought about it; I know that something is wrong, I don't feel loved, nobody loves me*—these

are all perceived imagination. You think or consider about it long before it transpires. Being too imaginative will allow you to have your own ideas and ownership. Imagination is a bickering aspect of wanting to control the person in authority. Our information about a person must be at all times viewed under the microscope of the Holy Spirit through the leading of the Lord. The lack of vision and the level of excellence act as hindrances to the growth of ministry. Wrong perception can and will stop the flow of the spirit. This type of spirit is mostly seen in the worship team and choir. We tend to interview people by their singing and not by the anointing. Satan demonstrated the lack of agreement because he allowed his vain imagination to dominate his conscience and as a result acted wrongful by deceiving Adam and Eve. We are to stop blatantly injuring one another because of wrong conception. As he thinketh so his he, says the word of God. Let us not be too desirous to be in control but be desired to work together in unity.

In my years of ministry, I have seen ambition to position surface so many times in the body of Christ to the point where it creates confusion, jealousy, and church split. But the remedy that the spirit of God allowed me to use was humility. He that exalted himself shall be abased, and he that humbles himself shall be exalted. As a result of that action taken, I was later promoted to that position and that individual went to another church—church hopping. We must be keen that our ambition can easily transform itself into selfish ambition. It's not about you; it's about God. It's not your ability, rather it is your availability. This is the trap into which Lucifer fell. His ambition to serve turned into an ambition to position.

Question! Was there a gap or opportunity in heaven that caused Lucifer to crave for position? No! He simply forgot who the creator was. Who appointed him? Who gave him authority? Any time a believer starts to disrespect leadership and implement his own duties such manifestion is rooted in the spirit of pride Whenever there are loopholes in the ministry, the devil will use tactic (jealousy, rebellion, disunity, etc.) to fill that gap. Demons can only enter an opening whether you believe it or not.

As soon as that spirit of Lucifer departed, the church began to grow drastically and members were added monthly to the church. Sometimes we will have three to four baptisms for the month, with a total of sixteen members added in the space of two months. The distasteful part of the cake

is that the person resigned his position without any public gratitude to the church board and members in general. He left with a bad attitude—period. Jesus said that a city divided against its self cannot stand (Matt. 12:25).

Never resign from pastorate without restitution of all disputes so as to lay a solid foundation for you and your family for the future.

Ten

The Anointing Knows the Wiles of the Devil!

The sole primary purpose of the anointing is for spiritual breakthrough. On the other hand, however, its main ingredient is consecration, which fuels the *catalysis* of the anointing. This defines or identifies the believer who is under the true anointing, so in a nutshell the anointing helps to identify or expose the devil's divisive spirit in the operation. Yes! That which comes from above is pure, meaning no impurities. The anointing can be counterfeited and mixed with spiritual impurities. The Bible says he can transform himself to angel of light, and his ministers can also transform themselves to ministers of righteousness (2 Cor. 11:13–15). His perversion looks valid and acceptable but not real. It takes the discerning spirit to distinguish satanic behaviors. He can counterfeit good, but he cannot create it. He has only duplicates, but not the original.

He was perfect, he was wise, he was beautiful, and he was anointed. The Bible says he covered the throne of God and was free to come and go as no other angels. He was special, according to Ezekiel 28. No wonder iniquity filled his heart, because he had everything to his comfort. Isaiah tells us that he was talented and beautiful. He was heaven's associate pastor, and in authority second only to the Trinity. He was appointed personally to minister to them in their Triune presence.

The Holy Spirit revealed to me that "Lucifer was the progenitor of the first Church split through the medium of influence, motivation, and perversion." He further revealed that "The Church needs to be careful of who it invites to sit on its board of administration." Be careful who you invite in the pulpit. Spirit can be transferred, thus becoming contagious to the body of Christ. The same way the anointed can be imparted and

tangible, the same with evil spirit. However, the stronger one will always last, as with the body of Christ—only true and genuine leadership last. Many are deceived by what they see and hear in the natural flesh and not by what the Spirit of God revealed to their spirit. Sign and wonders will follow the believer.

He was heaven's associate pastor at that time to be precise. He had a duty to play and that was to entertain God with worship. The moment you take your eyes off God and begin to do your own thing, you are in for a great fall. Peter, for example, when seeing Jesus walk on the water, thought it was a ghost beckoning him to walk on the water also. He started out well, but as soon as his focus shifted to self, he started to sink deeper and deeper. Jesus came to his rescue. Lucifer's focus was shifted to pride where he was distracted from his worship by a glance of his own image. His heart was filled with the wonder of his own appearance and authority. As a result of this, one third of angels in heaven followed him.

ഔരു

The wiles of the devil speak of his subtleness and cunningness that he frequently used against the body of Christ to achieve his plans.

ഔരു

It takes only a moment for your focus to change. It does matter the years of ministry and maturity. All can be lost if your focus is shifted by pride and rebellion. We have to be sensitive to how we adore ourselves in the mirror. Let us maintain our ambition in the spirit and not in the flesh of our mirror. We can idolize ourselves. The Bible makes special reference to the adorning of one's self: "Let it be the hidden man and not the outer man" (1 Peter 3:3–4).

Who causes the havoc? Who splits the church of unity? The associate pastor, Lucifer—the anointed cherub. Don't be fooled by the appointing! Be concerned about the anointing. Don't be surprised as to who will split the church. The closest one second in command is who you considered to be anointed, but deep within there is another person that is personified by another spirit. He is the Lucifer! Is God in Church splitting? No! He will allow it to happen, but he will never command it. During my years of ministry, one of the most troublesome officers that brought jealousy, strife, and contention in the church points to the associate pastor. The Lucifer spirit is most pervasive among people involved in a support ministry: associate pastor, music minister, cell group leader, elders, Sunday school teacher, etc.

These open doors of manipulation, domination, and intimidation. We are inviting more harm than restoration. An associate leader sometime brings more harm to the church than restoration—period. The wiles of the devil speak of his subtleness and cunningness that he frequently used against the body of Christ to achieve his plans.

Eleven

Be Sober Minded

In 1 Peter 5:8–9, the following analogy is given in admonition to the wiles of the devil: "Be sober, be vigilant; because your adversary the devil, as a roaring lion, walking about, seeking whom he may devour; whom resisted steadfast in the faith, knowing that the same affliction are accomplished in your brethren."

From the above passage, the apostle Peter outlines a few steps to be taken when up against the wiles of the devil: soberness, vigilance, and resistance.

The anointing comes with soberness of mind to spiritually equipping the believer, psychologically and morally. From the above passage, the first operative word is *soberness,* which means "to be in the right frame of mind; to be alert and sound." It simply means to be in control and not to act or speak foolishly or irrationally. It is closely associated with watchfulness and wakefulness as in the following passages (1 Thess. 5:6, 8; 1 Pt 1:13).

Be Vigilant

Know your enemy—the battle of the three

The Church of God, God's embassy, is up against three contending, resolute, tenacious foes whose motto is "No Retreat, No Surrender." These great foes are the world, the flesh, and the devil. Of these, the greatest adversary is Lucifer, the archenemy of mankind and the opposer of God and the church. Our conflict with the world and with the flesh would not be so intense if there were no Lucifer to contend with. For surely we would have a better place to live and enjoy our livelihood free from wars and rumors of wars, corruption, and crime. The world would be a

paradise of peace with no temptations and no battles to fight, if Satan was not created.

The famous proverb back home is "Life brings challenges and challenges bring changes." Whatever challenges proceeded in heaven sure brought forth a dynamic change in the utterance of this world that exists to this day. This change has erupted a volcanic explosion of exposition of sin's decay and moral fiber, affecting the era of the first government of God, resulting in a new human race called *man*. From this very day until now, the forces of good and evil have existed together; awaiting the harvesters—the day of conclusion. It is a day that will distinguish or reveal the wicked and just, tares and wheat, flesh and spirit, at the second coming of Christ. With this parable, the believer's hope is assured in the present ages to come, recorded in the holy Scriptures (Matt. 13:37–43).

Although the power of the cross had freed us from the law of sin, our battles are not over until the final showdown with Christ and Lucifer. We have three battles that depend on the choices that determine the course of our life—knowingly and unknowingly. And our first conquest is to seek ye first the kingdom and its righteousness and all these things will be added. Applying the road map is success from the enemy's booby trap and overcoming the influence and manipulative world system. The righteousness of God (breastplate of righteousness) will always guide your mind and heart from the deceptive allurement of the world. And the kingdom of God will prepare and teach you how to resist the wiles of the devil. You will know his tact and be properly trained. Moses was trained and mentored in Pharaoh's temple for such a time like this. The kingdom will prepare you to battle with Lucifer. And finally, the combination of both gives you the armor to withstand the fiery darts of the enemy. You will be clothed to battle with the flesh.

The real power behind every battle is Satan. The battle with self is Lucifer. The battle with the world is Lucifer. He will never give up!

Twelve

The Purpose of the Anointing on Your Life

Many people who are operating in the anointing don't know the true purpose of the anointing and how to use this power when manifested on their life.

Power for Service

Jesus had both power and authority. This was displayed after he descended on the Mountain of Temptation, where he was tempted by Satan for forty days and forty nights. In your greatest temptation lies the greatest breakthrough of power and authority.

> In your greatest temptation lies the greatest breakthrough of power and authority.

The hotter the battle, the sweeter the victory, and the more the anointing increases, the more self increases also. Therefore, when we are tempted by Satan and overcome, it is proved to God that we are now qualified and ready to be anointed for service.

The Bible says that Jesus returned in "super dunamis" power of the Spirit, and news about him spread throughout the entire vicinity.

Jesus was so connected in the Spirit that even his countenance cancels the power of darkness. His teachings bring convictions to the most nobles men of the law. (See Luke 4:14–15.)

The anointing on Jesus' life hit the news media of Galilee, Nazareth, and Jerusalem like a bullet from a rifle. Jesus was given power for service in the heat of temptation for those forty days and nights.

Later Jesus went to Nazareth and declared the greatest sermon of the anointing,

> The Spirit of the Lord is on Me because He has anointed Me to preach good news to the poor. He has sent Me to proclaim freedom to the captives and recovery of sight to the blind, to set free the oppressed, to proclaim the year of the Lord's favor (Luke 4:18–19).

Lack of power in the pulpit and pew are a result of not having the anointing through consecration and sanctification.

The anointing bring liberty to the captives, setting the oppressed loose of demonic yokes.

Power to Preach

Jesus declares in the Gospel of Luke that "the Spirit of the Lord is upon Me to Preach." Preaching is the ability to proclaim the word of God with *dunamis* of the Holy Ghost. It is not mere words of eloquence but rather words with power from above that bring fire to the bones with signs and wonders to the world.

Knowledge of the word of God is not enough, especially in these trying times, to break the bonds of Satan. Words are powerful but only if spoken in faith with great assurance of confidence for it to have effect on the situation. A thorough study of the word is important (2 Tim. 2:15) to impart to your congregation. The anointing is the key to mission in our sermon delivery; we speak as an oracle of God with authority and boldness.

Too many times we see preachers of high caliber, masters of pulpit etiquette, refined and homiletically flawless, but the only missing piece to the puzzle is the absence of the anointing. This makes one powerless in these settings and even brings embarrassment to the council of heaven and other leadership.

There is, therefore, no equation for preaching other than the anointing. No passion, no zeal can make up for the lack of anointing on our lives. The job of the Holy Spirit is to inspire and anoint us, to make us preach boldly before the throne of iniquity, dismantling the powers of hell (Jer. 5:14), and to set fire to the enemy's camp that breaketh the rock in pieces (Jer. 23:29) with igniting power (Isa. 55:11).

Thirteen

Benefits of the Anointing

Power for Evangelism and Mission

One day I decided to go in the inner city of a particular community to witness primarily to the souls of men. Jesus always sends out his disciples two by two for many reasons, but this time it was me and God. There was no one with me, but I know for a fact that the Holy Spirit was with me as I obediently went to this community. Was I afraid? No! I know God was with me, and certainly he was.

As I continued to walk down the road, I saw my greatest passion: *men*. As I started witnessing to one person, the presence of the Lord began to manifest itself and gradually another one came. Before I knew it, I was ministering to a crowd. My heart was so overwhelmed to know that the hearts of men were so receptive to the word of God. That day, those men were indeed blessed, while few of them got converted and were baptized.

We are given the greatest commission in history with an international license that is not revocable to preach the word of God. This great commission carries with it the promises of the anointing of the Holy Spirit. "And remember I am with you always, to the end of the age" *(Holman Christian Standard Bible)*.

Scripture readings: Matt. 28:18–20; Mark 16:15–16; Luke 24:47–48.

This commission comes with authority and power. He instructed His disciples to go and tarry at Jerusalem for this power. It is crucial that we are anointed before we take up the mantle of the "Fivefold Ministry." Jesus knew the importance of the anointing for his disciples to fulfill the

mandates. We don't need the commission; we need the anointing to do the mission.

> But he shall receive power after that the Holy Spirit is come upon you: and ye shall be witnesses unto me both in Jerusalem and in all Judea and Samaria, and unto the uttermost part of the earth (Acts 1:8).

This power was the initial preparation for the disciples—to be equipped for spiritual tasks. Without this power, they would not be able to spread the gospel. In obedience, they returned to Jerusalem and tarried for ten days, praying and waiting on the promise of the Holy Spirit. (See Acts 1:14.) The Holy Spirit in the realm of intercession came upon them and baptized each one with power, thus equipping them for this great commission. Onward, they were empowered to preach, heal, and do wonders in the name of Jesus.

ഇരുന്ന

Missions are specific and commissions are general.

ഇരുന്ന

> And they went forth and preached everywhere, the Lord working them, and confirming the word with signs following (Mark 16:20).

I believe strongly that the anointing is for the *marketplace*. Paul and Barnabas were summoned by the Holy Spirit to do missionary evangelism. Missionary evangelism is given specific mandates to follow and carry out task or works wherever thou goest. They were mission evangelist, called and sent just as in the case of an apostle. To evangelize is to share or spread freely the word of God.

Out of *commission* comes specific *mission*. Paul and Barnabas here were given a specific task to the Gentiles from the church in Antioch. They prayed and fasted and the Holy Ghost spoke that they should be the two to go. It is worth mentioning here that "everyone needs a covering to intercede for them while on the field of missions." The Apostles laid hands on them and as they received the Holy Ghost power for service and then sent them forth. Let us not fool ourselves that we are so anointed that we don't need covering and backup.

Every Watchman Needs a Watchman

These two went forth under the anointing with full support in prayer and fasting from the church. It is best to travel in two or groups whenever on missions. At Paphos, they encountered a false prophet, a witch called Bar Jesus or Elymas, who opposed them in different spiritual warfare. The anointing on Paul's life dismantled the powers of witchcraft that day bring glory to GodPaul was victorious that day with his first spiritual battle with Barnabas. (See Acts 13.)

The anointing here exposed their deeds and convicted them to Christ. The power of the Holy Spirit discerns. Rebukes. and dismantles their demonic forces. What about you, my friend? Can you do the same if you walk in the anointing of God?

I believe this anointing is on your life too to go out and minister to someone. Go, my friend; the Lord is with you right now as I speak to you. Take up the mantle and fulfill this calling on your life, in the name of Jesus.

Spiritual Battle

We need to be spiritually armed and equipped for spiritual battles. Our warfare is not a natural one. It is a spiritual one.

Jesus Christ was anointed to fight and destroy the plans of Satan (1 John 3:8). God had first anointed his son before he could fulfill his redemptive mission on earth. He was anointed with measures of the anointing to destroy the works of Satan.

It is necessary to bear in mind that Satan was not an ordinary angel; he was the sun of the morning, the anointed Cherub that knew and beheld God. (See Ezekiel 28.) He was the anointed among the cherubim. Jesus was the only one that could destroy Satan because he was the one (God) who created and knew the wiles of Satan. His head was bruised by the power of the anointing. (See Col. 2:15.)

To Break Yokes

Without the anointing there will be no miracles and supernatural deliverance. (See Isa. 10:27.) In deliverance ministry, the anointing

is a must to crush the deeds of Satan. This is the best place where the spirit of Satan and his cohorts lurk around. This is where I personally experience and see the most demons manifested.

ഇ൫

Lack of knowledge
is a result of lack
of teaching and
submission.

ഇ൫

The seven sons of Scever were disappointed because the anointing was not in their favor to work to their pleasure and motives. The demons were not impressed with their presumption and insulted their power of belief. They were overpowered. Yokes are like rocks and the anointing like hammers. The hammer's job is to break the stones into pieces and the anointing is to destroy yokes.

To Teach

The fivefold ministry is given to the church "for edification, exhortation and encouragement ... until we have come in unity of the faith ..." Ephesians 3. Hence, it is a foundational gift. Teaching with the anointing is the supernatural knowledge, wisdom, and pattern of God created in the throne room of heaven. Not everyone can teach because there is a special anointing for this.

Jesus taught with the anointing and authority. He was different from the school of prophets, scholars, and rulers around because of the presence of the anointing that convict and convince them of Christ, the savior. Teaching of the word of God makes you more rounded and sheds more light on those dark cell membranes of your life. Teaching connects you to a more personal relationship with God because you know him more through his word.

The Holy Spirit is the best teacher. The Jewish council was afraid of the disciples simply because they taught with the anointing. To know the Scripture is good, but to explain it with the anointing is better and more convincing and convicting, which was what took place with the disciples—period.

And it came to pass, when Jesus had ended these saying, the people were astonished at His doctrine: For he taught them as one having authority, and not as the Scribes (Matt. 7:28–29).

To Sing and Play Music

Songs when ministered under the power of the Holy Spirit transform the body of Christ by expelling evil spirits, removing burdens, releasing depression, and welcoming more "celebrational worship" (1 Sam. 16:19–23).

To Lead Worship

Joshua and the children march around the wall of Jericho in praise and worship with the anointing. Jehoshaphat and the choir, all assembled together worshipping in the anointing and later got the victory.

To Witness

The anointing is needed to show the fruit of the ministry. When Peter received the baptism of the Holy Ghost, he witnessed and preached the word of God and 3,000 souls got saved. Winning a soul requires the anointing. (See Acts 1:8.)

To Offer Word of Wisdom

This is the heavenly wisdom of God in shepherding and directing the sheep, so that the life of the person will be saved and restored when the wisdom of God is offered with the anointing. One will be able to discern and assure the person more without supposition and assuming. (See 1 Kings 3:16–28; Isa. 50:4–5; James 3:17.)

To Testify

Testimony is a weapon that destroys the bonds of the enemy and therefore is a force of encouragement to many. An anointed testimony gives hope and faith to continue on the battle field.

> Your testimony is subduing power that denies the enemy of victory over your life.

The Bible says, "and they overcome by the blood of the lamb and by the word of their testimony " (Rev. 12:11; 2 Tim. 1:8; Sam. 17:32–37, and Mal. 3:16). There is power in testimony. It is a source of strength to the body of Christ that sustains the individual in time of difficulties. Satan cannot stand it when you testify of the goodness of God's glory. It brings defeat to his kingdom and edification to the church, thus giving glory to God.

Fourteen

The Dogma of the World's Standards

Great success in life is never easy to attain when one thinks of the great challenges and hard work that is always required. The sacrifices, the disciplines of self-control, and the determination to aspire academically all summed up to the notion "to make the world a better place to live." What is life without success? What also is life without Christ? Which is the greatest?

Many of us will ask ourselves these questions: *Is success all? Is Christ the answer to success?* The missing formula in any achievement is most of the times forgotten in public forum, celebrity, conferences, and awards. Probably we don't know what the greatest success in life is or that life brings. It has nothing, however to do with our superb invention, knowledge investment, prosperity, and famous celebrity. The greatest recorded success ever in human history is the birth of Jesus Christ and his crucifixion—that is success! Rick Godwins profoundly says, "It is the crucifixion of Jesus on the cross." Living a successful life with all the achievements behind your name is void without Jesus Christ in your life.

> The path to a successful life is putting Jesus first.

The true meaning of great success is fulfilling God's purpose for your life. When God's purpose is accomplished first, then all other successes will come in advance, in excess, and even in abundance. (See Matthew 7.) For with God, first and foremost, all things are possible. He is able to do exceedingly and abundantly more than we ask whenever we commit our lives in his hands. Again the wise book of Solomon reminds us, "Trust in the Lord with all thine heart and lead not unto thy own understanding,

but in all thy ways acknowledge Christ and he will direct your path" (Proverbs 3:5–6). The path to life is putting Jesus first.

Satan is real and does exist today, just as he did when Adam fell. He is the prince of the air, meaning he governs the air. His aim is to control the world through the spirit of influence, depraving the holistic attributes of God. His aim is to fight the standards of God. As the governor of the air's capital, his diabolical influences and manifestations can be felt, sensed, and seen everywhere. By reason of this nature, the world is unable to submit to God's righteous government because we have not fully surrendered at the cross of redemption. When we do this, we will release ourselves from the law of sin's dominion, giving precedence to the work of the Holy Spirit to regenerate us by submitting to the doctrines of God in our life.

In doing so, we are not under his portfolio. Therefore, we are released from all worldly pleasures, deceptions, enticements, pressures, judgments, and the world's concepts. We are born again so to speak. A new creation!

> ೲೞ
>
> The force of evil was always present since the fall of Lucifer and the fall of Adam and Eve.
>
> ೲೞ

We are no longer living in self-denial under the bondage of sin and being a slave to sin. By this way of life, you and I shared and fellowshipped in the victory and defeat of the devil's principalities and powers of hell through his death on the cross and his resurrection from the dead.

In the spirit world, there are two opposite forces in operation, not equal though: the power of God and the power of the devil. God is the source of all power, goodness, truth, righteousness, and godliness, but Satan is the father, originator, and perpetrator of all sin, evil, wickedness, and rebellion.

Numerous Greek words are associated with *world*. These definitions vary but still maintain a relational meaning in their context of content. There are three New Testament Greek words for *world*. The first Greek definition for *world* is *oikoumene,* which means "inhabited earth" (it is used of the whole inhabited world, Matt. 24:14), which is normally seen in a country that is run by the Roman Empire, or a monarchy. They are responsible to govern any country that falls under their jurisdiction. A degree or law was always given at an appropriate time as in the book of Luke 2:1, which required the participation of all members under the

headship or colony of that law and country. For example, "when Caesar Augustus called a census throughout the earth, it was observed and done by all the Roman Empire in their geographical location" (hometown).

The second word for *world* is *kosmos* (or *comos),* which means "primarily order, arrangement, and adornment." This is the most frequently referred one that is used by many people, whether in the right context or not. The meaning of this word is interchangeable to the different phrases used in the word of God, such as "the prince of the air" and "wickedness in high places." It is used in this manner to denote a place of spiritual realm that is controlled by the spirits of this world. This definition does not refer to the physical earth but a realm where certain things happen a certain way. Jesus was keen to this when he sat and prayed to his father for the disciples.

> I pray not that thou shouldest take them out of the world, but that thou shouldest keep them from evil. They are not of the world, even as I am not of the world (John 17:15–16).

> Our father who art in Heaven lead us not into temptations but deliver us from evil for thy will is the kingdom, the power, and glory forever. Amen (Matt. 6:9–13).

> Yea thou I walk through the valley of the shadow of death, I will fear no evil for thou art with me …" (Psalm 23).

According to John's Admonition

And we know that we are of God, and the whole world lieth in wickedness (1 John 1:6).

The force of evil was always present since the fall of Lucifer and the fall of Adam and Eve. Jesus knew the days would come when you and I have to battle with the present evil of this world. The principles of God never changed because he is immutable in character, attributes, and holiness, but the standard of the world always changes as a result of the methods that are used by Lucifer to influence the world. The standards of the world would not see through this light of Jesus being our greatest success; instead the *strongholds* of their lives would see otherwise. By nature of this, the world's system is unable to submit to God's righteous government, but by

God's standards he was totally victorious. The Lord came into this world to demolish the works of Satan.

The third word for *world* is *aion*. It refers to an old age of time or a period marked by time. Its usage in the New Testament is marked by spiritual or moral characteristics of the end of the world. (See 1 Cor. 10:11; Gal. 1:3–4; and Luke 16:8). It also signifies the divine fulfillment and purposes concerning the ages in regards to the church. This is in relation to Christ Jesus who gave himself for our sins, dying on the cross to rescue us.

> Who gave himself for our sins, that he might deliver us
> from this present evil world, according to the will of God
> and our Father (Galatians 1:4).

The Church in the World

The church is a called-out body transforming the world from darkness to light. The church's aim in the world is to shine light in every pinnacle of dark cells, changing the lives of people and building the futuristic kingdom to come. We are not to abide by the world's order because we are the light and the salt to the world and not of the world. We are to add and not take from the world in both spiritual and physical aspects (1 John 4:5–6).

The church is the DNA to prevent the spread of viruses in the body of Christ. We must not fear the red blood cells but rather deactivate their plans to gain control, hence having access to the kingdom of God.

The Deeds of the Flesh

The most troublesome element of the body is the flesh. The flesh is the troublesome element of the body that works against the spirit of God. Apart from the creative aspect and intended purpose of the flesh, it is construed to that code of transmission through which sins enter the human race. Out of this, therefore, spring forth the natural tendencies to desire, lust, and being sexually drawn to the opposite sex, making it an instrument of self-gratification and exploitation. But it should be committed to love, faithfulness, and the miracle of new life, as God intended.

But out of evil comes forth good, which is Galatians 5:16 "Walk in the spirit and he shall not fulfill the lust of the flesh." The works of the flesh were to disgrace mankind, but thanks to God the fruit of the spirit came in and nullified the deeds of the flesh on one condition: to live and walk in the spirit at all times.

Paul, the servant of God, walked in the fivefold ministry, and battled enormously with the flesh even though he was an apostle. Did God allow that to happen? Yes! As Christians, we must realize that this old nature will never be destroyed until the return of Christ. We were created anew when we came to Jesus Christ, but he did not remove our sinful Adamic nature. Our sinful Adamic nature is in our fleshy thoughts, so while living on earth we will still encounter trials and tribulations.

Paul gives us an exclusive list on the deeds of the flesh and then provides us with the tool to the answer—execution. (See Galatians 5:24.) "Now those that belong to Christ Jesus have crucified the flesh with its passions and desires." The evidence for declaring that you are a child of God is to crucify the deeds of the flesh. Christ knows us through the eyes

of the Spirit when he sees his blood on us. Mortifying the flesh is simply to discipline its actions whenever it increases. The only alternative measure is to die to self and let the Spirit of God reign within us periodically. It is not a friction story I am trying to get across the table but a living fact so as to keep you and me alive in the presence of God.

We must not let our actions determine our attitude in the body of Christ.

The flesh and the Spirit are enemies; they work in opposition to one another. "For the flesh lusts against the Spirit, and the Spirit against the flesh; these are in opposition to one another" (Gal. 5:17). The word of God says again in Romans 8:8, "So then they that are in the flesh cannot please God." Even when we do the right things with selfish motives, we still cannot please almighty God that way. We must not let our actions determine our attitude in the body of Christ. When we are controlled by the flesh, we block our own breakthrough and act contrary after blaming others when it is our fault.

> The Bible says in James, "Then when lust hath conceived, it bringeth forth sin: and sin, when it is finished, bringeth forth death" (James 1:15.)

The ball is in our court; therefore, the responsibility of killing the deeds of the flesh definitely belong to us. To live with Christ, Paul declared, "But if ye through the Spirit do mortify the deeds of the body, ye shall live" (Rom. 8:13). The choice is yours, my friend. Christ did his part so the rest lies with us.

A Brief Study of the Deeds of the Flesh (Galatians 5:19–21)

Most of the meanings and definitions are taken from *Expository Dictionary of New Testament Words* by W.E. Vine, unless otherwise stated.

"Adultery" (vs. 19): The Greek word rendered *adultery* is *moichos*: "Unlawful intercourse with the spouse of another" is the common definition of *adultery*.

"Fornication" (vs. 19): "Fornication" is derived from the Greek *porneia* and means "unlawful sexual intercourse" (Vine). *Fornication* is a broad word that often includes adultery. The Scriptures succinctly teach, "Flee

fornication" (1 Cor. 6:18). Therefore, those who walk, live, and are led by the Spirit "shall not fulfill the lust of the flesh" (vs. 16).

"Uncleanness" (vs. 19): *Akatharsia* is the term that is here translated "uncleanness." This term is a little elusive as far as assigning a precise meaning. In general, "impurity and moral filthiness" is the idea. Moreover, "uncleanness" is a word that is used to describe the most basic of sins and sinners (Rom. 1:24–32). The child of God is not called to uncleanness (1 Thess. 4:7).

"Lasciviousness" (vs. 19): *Aselgeia* means "Excess absence of restraint, indecency, wantonness" (Vine). The highly recognized Henry Thayer comments that "lasciviousness" *(aselgeia)* pertains to indecent bodily movement, unchaste handling of males and females."

"Idolatry" (vs. 20): *Idolatry* is translated from *eidololatria* and is the placing of anything or anyone over God (Col. 3:5). In placing God first, the saved avoid idolatry (Matt. 6:33, 24).

"Witchcraft" (vs. 20): *Pharmakia*, the original word, is an interesting term. This word is rendered *sorcery* in most translations. "Primarily signified the use of medicine, drugs, spells and magic As well as much of the New Age Movement in general. Christians that follow the teaching of the Spirit will destroy all such influences and will free their lives of practices" (Acts 19:19).

"Hatred" (vs. 20): *Echthra* is the opposite of love or *agapa*. *Echthra* is usually rendered *enmities* in many translations. Those under the guidance of the Spirit replace *enmity* with *love* (Matt. 5:44).

"Variance" (vs. 20, *eris*): *Eris* is translated to *strife* in a number of works. Strife is the product of hatred or enmity. However, endeavoring to be "of one mind" and possess love will remove strife (1 Cor. 1:10; 1 John. 3:11).

"Emulations" (vs. 20, *zelos*): *The American Standard Translation* renders *zelos* (word for zeal) "jealousies." One commentator wrote regarding *emulations,* "Painful feelings, anxious fear, and unfounded suspicions aroused in the heart over the excellencies of others, unholy desires to excel one another." Walking in the Spirit precludes such zealous desires (Rom. 12:15).

"Wrath" (vs. 20, *thumos*): *Thumos* is a strong word meaning "hot anger, passion" (Vine). The Spirit teaches: "But now ye also put off all these; anger, wrath, and malice out of your mouth" (Col. 3:8).

"Strife" (vs. 20, *erithia):* "Denotes ambition, self-seeking, rivalry, and self-will." James wrote that where such a spirit prevails, "there is confusion and every evil work" (James 3:16). It is of interest that James' statement occurs in the sitting of discouraging men from "hastily" becoming teachers (James 3:1). If one seeks to serve others out of love, such a spirit will not be present (Gal. 5:13).

"Seditions" (vs. 20): The word *dichostasia* means "literally a standing apart, hence division" (Vine). The curse of God rests on those who pervert the gospel and bring another gospel (Gal. 1:6–9). Those who truly love the Lord and heed the teachings of the Holy Spirit will promote unity by teaching the doctrinal oneness of the gospel (Eph. 4:3–7).

"Heresies" (vs. 20, hairesis): *Heresies* is an English word some select to translate *hairesis.* The Greek *hairesis* means "a choosing, choice" then "that which is chosen, and hence, an opinion, especially a self-willed opinion which is substituted for submission to the power of truth, and leads to division and the formation of sects" (Vine). Concerned reader, have you noticed how the "works of the flesh" produce division among God's people ("variance," "strife," and "seditions")? When the Christian yields to the influence of the Spirit (teaching of word), he will deport himself in such a way as to discourage sinful division (Cor. 11:19).

"Envyings" (vs. 21, *phthonos):* This original word is defined as "feeling of displeasure produced by witnessing or hearing of the advantage or prosperity of others" (Vine). How opposite of the Spirit's teaching: "Rejoice with them that do rejoice, and weep with them that weep" (Rom. 12:15).

"Murders" (vs. 21, KJV): "taking the life of a person."

"Drunkenness" (vs. 21): Drunkenness *(methe)* is an indication of lack of control and is unquestionably denounced in the Scriptures. In fact, the godly are warned not to ever "look upon" such intoxicants (Prov. 23:29–35; medicinal use is the only exception: 1 Tim. 5:23). When one is "filled with the Spirit," one has no use for strong drink (Eph. 5:18).

"Revellings" (vs. 21, *komos): Komos* has a basic meaning of carousals and lack of restraint. Notice the climate in which Peter used *komos:* "For the time past of our life may suffice us to have wrought the will of the Gentiles, when we walked in lasciviousness, lusts, excess of wine, revellings, and abominable idolatries" (1 Peter 4:3).

"Such like" (vs. 21): Any particular not stated in the foregoing enumeration of the works of the flesh is here designated in "such like" *(omoia)*. Gambling, the modern dance, and so many additional specifics that look to the flesh for their origin and nature fall into the designation *such like.* Paul makes it very plain that "they which do such things shall not inherit the kingdom of God" (vs. 21).

One of the greatest contrasts found in the Bible is next presented. "But the fruit of the Spirit is love, joy, peace, longsuffering, gentleness, goodness, faith, meekness, temperance: against such there is no law" (Gal. 5:22–23).

Sixteen

The Fruit of the Spirit

The phrase "fruit of the Spirit" is singular in comparison to the gifts of the spirit, which is in its plural state. It is *fruit*, not *fruits*. The fruit is one; does not bear discord, dissension, and distorted children. The works of the flesh are many, which is the safest way to detect its behavior, temperament, personalities, and devilish appearance because they are many. The devil in the man when he saw Jesus quickly declared that they were many legions. The manifestations of the flesh are always many while the manifestation of the fruit is one—the same (few). Love is no different from love.

ഈ‍രു

The fruit of the spirit is the character of God. The gifts of the Spirit is the power of God.

ഈ‍രു

The gift is already there, according to Ephesians 4 and Philippians 4:17. "He gave gifts unto men ..." (Ephesians 4:8). We need the fruit of the spirit to manifest the gifts of the Spirit.

We need the fruit! We need to bear the fruit. In the fruit of the spirit, you have the different gifts. You have to bear to manifest and not the opposite. You have to bear the fruit of the spirit to manifest the gifts of the Holy Spirit.

What is the fruit? It is the character that accompanies the manifestations of the gifts of the Spirit. The fruit of the Spirit is one, but its manifestations are many—the gifts. It is also the evidence, sign, mark, or manifestation of the nature of a thing (Matthew 7:15–20; 3:8).

Fruit means work. Fruit of the Spirit is the gifts of the Holy Spirit within you (2 Peter 1:3). The gifts are the manifestations of the fruit of the Spirit.

Fruit is character you possess while gifts are in manifestations. This is why the Bible makes it very plain and straight on the principle of love. You can serve without love. You can operate in the gifts or under the anointing without love. You can be strong in one and weak in the other, but this is certainly contrary to the work of Christ.

It means the effect or evidence of the Spirit of God in your life. This is the character of the saints. It is the character of God.

Since we have been born of God by his Spirit, we have the *life of God*—His Presence—himself—within us in our new man. But rather than being content with regeneration, Paul exhorts us to walk in the Spirit by conforming our lives to his character (Gal. 5:25). The flesh, which we have by nature, and the Spirit, which we have by regeneration, are opposite. They hate one another. They war against one another. They are the reason for our state of conflict while in the body (Galatians 5:17).

In Galatians 5:22–23, the fruit of the Spirit includes the following:

"Love" (Gk. *agape)* is a caring and seeking for the highest good of another person without motive for personal gain (Romans 5:5; 1 Corinthians 13; Ephesians 5:2; Colossians 3:14).

"Joy" (Gk. *chara)* is the feeling of gladness based on the love, grace, blessings, promises, and nearness of God that belong to those who believe in Christ (Psalm 119:16; 2 Corinthians 6:10; 12:9; 1 Peter 1:8; Philemon 1:14).

"Peace" (Gk. eirene) is the quietness of heart and mind based on the knowledge that all is well between the believer and his or her heavenly Father (Romans 15:33; Philemon 4:7; 1 Thessalonians 5:23; Hebrews 13:20).

"Longsuffering" (Gk. *Makrothumia)* is endurance, patience, being slow to anger or despair (Ephesians 4:2; 2 Timothy 3:10; Hebrews 12:1).

"Gentleness" (Gk. *chrestotes)* is not wanting to hurt someone or give him or her pain (Ephesians 4:32; Colossians 3:12).

"Goodness" (Gk. *agathosune)* is zeal for truth arid righteousness and a hatred for evil; it can be expressed in acts of kindness (Luke 7:37–50) or in rebuking and correcting evil (Matthew 21:12–13).

"Faith" (Gk. *pistis*) is faithfulness, firm and unswerving loyalty, and adherence to a person to whom one is united by promise, commitment, trustworthiness, and honesty (Matthew 23:23; Romans 3:3; 1 Timothy 6:12; 2 Timothy 2:2; 4:7; Titus 2:10).

"Meekness" (Gk. *Prautes*) is restraint coupled with strength and courage; it describes a person who can be angry when anger is needed and humbly submissive when submission is needed (2 Timothy 2:25; 1 Peter 3:15). For meekness in Jesus, compare Matthew 11:29 with Matthew 23 and Mark 3:5. In Paul, compare 2 Corinthians 10:1 with 10:4–6 and Galatians 1:9. In Moses, compare Numbers 12:3 with Exodus 32:19–20.

"Temperance" (Gk. *egkrateia*) is having control or mastery over one's own desires and passions, including faithfulness to one's marriage vows; also purity, chastity (1 Corinthians 9:25; Titus 1:8; 2:5).

According to Rev. Claue Purser, "Paul's final comment on the fruit of the Spirit indicates that there are no restrictions to the lifestyle indicated here." "Christians can—in fact, ought to—practice these virtues over and over again; they will never discover a law prohibiting them from living according to these principles."

In closing, the works of the flesh are degrading to mankind and a threat to society itself. Nothing good ever came from *enmities, envying*, and *drunkenness*. To the converse, *love, gentleness,* and *goodness* are uplifting and beneficial to the community and society. Remember that Paul wrote that those who "walk in the Spirit shall not fulfill the lust of the flesh" (Galatians 5:16). When love is present, how can such works as *hatred, variance, emulations, wrath,* and *strife* find a place to lodge?

In the climate of *peace, seditions, heresies,* and *strife* cannot thrive. *Gentleness* or kindness precludes works such as *wrath*. If we allow the Spirit to nurture and educate us, we will not have to focus on battling the works of the flesh. You see, by following the Spirit through the teaching of His word, we acquire traits and will manifest the fruit of the Spirit that will preclude or displace the works of the flesh.

As we have seen, the works of the flesh and the fruit of the Spirit cannot coexist. This is why the inspired text says, "Walk in the Spirit, and ye shall not fulfill the lust of the flesh."

Seventeen

Experience of the Anointing

What Is the Anointing?

The anointing is the double portion of God's power that transpires with the emblems of the Holy Spirit so superbly that the natural man cannot fathom. It is the now power as the Holy Ghost descends from above on the life of that sanctified believer who desires to pay the cost personally to go deeper in the realm of God's network. The anointing is the invested mantle of authority through the Holy Ghost to connect you to God by dismantling the powers of darkness.

The anointing is the biblical term for the "supernatural power of God." Another name for the anointing is *unction*. The terms are used simultaneously and interchangeably in 1 John 2:20, 27. Both words are translated from the same Greek noun *chrisma*. It is used figuratively as the endowment or bestowal of the Holy Spirit upon the saints. It is the corresponding noun of the Greek verb *chrio* translated *anointed*. Thus *chrio* means "to anoint or to consecrate to an office."

> Every good gift and every perfect gift (anointing) is from above, and cometh down from the Father of lights, with whom is no variableness, neither showdown of turning (James 1:17).

The anointing is not something that one can define perfectly. It can be better described than defined, better experienced than explained. One really needs to have the experience to know what it is like.

❖ It is the fire of the Holy Ghost that purifies, consecrates, sets on fire, and blazes you for the glory of God.

❖ It is, therefore, "the ark of God" among his people. It is an emblem of authority with spiritual significance symbolizing the presence of God, which was illustrated in the Old Testament.

❖ It is the emblem manifestations of the Holy Ghost that accompany with signs and wonders when thoroughly empowered.

❖ It is the resurrection power that does not bring about dormancy, quenches the fiery darts of the enemy, raises the dead, and transforms one from ordinary to extraordinary. (See Mark 16; Eph. 6:16).

❖ It is the balm in Gilead, oil of joy, rain of God, that provides provision, gives restoration; declares repentance, and proclaims revival. (See Luke 10:34, 7:46; Exodus 27:20; Heb. 1:9; Isa. 61:3; and Ps. 45:7.)

❖ It is the robe of righteousness, helmet of salvation, beard of Aaron, horn of oil of David, apron of Paul, handkerchief of Peter, and garment of praise. (See Ps. 45:8; Ps. 133:2–3; Ps. 132:17; Acts 19:12.)

❖ It is the burden-removing, yoke-destroying, healing, and pain-removing power of God (Isaiah 61).

❖ It is that availability to sanctify power on the inside of you for boldness, courage, and double portion of power.

❖ It is that vehicle force in you that is able to drive away sickness, pain, discouragement, depression, frustration, and fear (2 Timothy 1:7).

❖ It is that enabling power to do exceedingly above principalities and powers in high places. (See Eph. 3:20–25.)

❖ It is that now power to defeat your adversary.

❖ It is the shadow of the almighty of Psalm 91, manna from heaven, and typology of Elijah's food (John 6:32–35; Numbers 11:8).

❖ It is the divine presence that equips, qualifies, and ushers us into particular office (Isaiah 61).

❖ It is the power that gives spiritual mandates to serve, authenticity and authority, power and purpose when called on (1 John 4:4; Luke 10:19).

❖ It is the only power that combats spiritual witchcraft, sorceries, etc. (Acts 10:38).

ᔥᔐ

The anointing is the supernatural power from above that equips and qualifies the individual for service.

ᔥᔐ

❖ It is the only power that exposes the influence of seducing spirits, deeds of the flesh, and evil spirits (John 3:20–21).

❖ It is that power that can shut the mouth of lions, close and reopen the doors of heaven, and dismantle and disarm Jezebel and Ahab spirits when manifested in full force (Daniel 6:22; 2 Timothy 4:17).

❖ The anointing or unction is the supernatural power of God upon the saints by which they are enabled to undertake supernatural tasks.

❖ It is the divinely bestowed power upon God's servant by the Holy Spirit.

❖ It is the divine presence of God or an aura of God's power and glory that envelops his minister.

❖ It is the divine insignia, a spiritual staff of office, an emblem of authority, a symbol of God's presence (Revelation 11:1).

❖ It is like "fire in the bones"—spiritual fire (Jer. 20:7–11).

❖ It is that fire power that accompanies the baptism of the Holy Ghost (Matt. 3:11, Luke 3:16).

❖ It is the sacred flame or Holy Fire that burns within the believer and sets him on fire for God and his work (Leviticus 6:12–13).

❖ Isaiah described it as "a live coal on his lips" (Isa. 6:6–7).

❖ It is like "heart burn within experience"—disciples on the road to Emmaus. Did not our heart burn within us while He talked with us … (Luke. 24:32)?

❖ It is like electric power—the story of Ananias and Sapphira (Acts 5:1–10).

❖ It is like a balm or ointment—oil is a symbol of the Holy Spirit. Oil is used for several purposes. (See Luke 23:56; Rev. 18:13; Matt. 26:6–13; Mark 14:3–4.)

❖ It is medicinal, preventive, reviving, and comforting like the "balm of Gilead" or healing ointment. The anointing heals wounds and infirmities. It flows with healing power, comforts the broken heart, and brings deliverance to the oppressed (James 5:13–14; Isa. 61:3; Ps. 45:7).

Eighteen

Personal Experience of the Anointing

Every new undertaking or new vision or new ministry requires a new anointing or endowment. We need new anointing for a new service, a higher level for higher calling or greater responsibility; for to whom much is given, much is also expected.

As a young man growing up in my teens, I personally witnessed and experienced the power of the anointing far beyond human knowledge. I am not making up any stories to gain a platform of recognition for this book. I am not telling a story and I am not semantic. In 1999, I was enrolled the evening classes at Kingston Technical to repeat fifth form. Being persistent in prayer and fasting, I was determined to get in the general school program, which came to success later.

The school curriculum consisted of a syllabus and another Christian program called Inter-School Christian Fellowship (ISCF), which was introduced to each student desirous of worshiping and fellowshipping after school with other inter-colleagues, schools, churches, and organizations. There were no special meeting places since sometimes there were only a few dedicated students who really loved the Lord and would appear over and over. I always attended, because I saw the need for changes and transformation within the club. One day, however, the Holy Ghost told me to tell the president to change the location of the evening worship to the first floor of the building. The building consisted of three levels, so we were on the top floor. I also told her to call that classroom "the upper room—Acts 2." To some, it was very erroneous and foolish, but to God it was ideally chosen. The president that day did as I instructed. Nothing happened that day, or the next day, but upon seeking the face of God, He (Lord) communicated to another young man who was apparently a teacher

of the said school with the same vision. So from there the young man and I were like Paul and Silas. We would pray openly at lunchtimes in the upper room and conduct services as the Lord leads.

Not every place is God's appointed place. God's appointed place comes with three signs: revelation, confirmation, and manifestation. Location can affect your destiny and breakthrough—see 1 Kings 17. We see this in the life of Elijah at the brook of Cherith and also at Zarephath. There are designated places where God will command the raven to feed you as well as there are designated places where he will endow you with power and favor.

Although the young man and I prayed earnestly each day, nothing transpired. The evening worship continued as usual, attracting more and more students, which to me were signs of revival to come. We kept on praying during the lunch hour until God started to send several students and we formed what church leaders called "a prayer group of sacrifice."

As the name suggested, we would make costly sacrifices to intercede for revivals, breakthroughs, and changes at the school. We were so committed to this ministry. I mean, we were sold out to God for His use and purposes. We were even seen as the holy saints, a set-apart crew in the school. As for me, I was their target for ridicule. They would laugh at me, make fun of my dress code, and do other hilarious things which to me were distractions of the devil.

The Day of Power!

During school one day, the Lord spoke vividly to me and said we must start praying. This was about 2:30 pm., an extra half hour before dismissal. We did not question the authority of God, because within that extra last thirty minutes the three of us did not have any class to attend. We gathered together laughing and having fun when God told me to tell them (friends) to start praying. As I said, we were obedient and did directly as the Lord had commanded.

After school was dismissed, we all went to the upper room in a rush to start service. Apparently, I left one of my books in the next building, which would take five minutes to retrieve. On my way going for my book, one of my fellow schoolmates started to laugh at my uniform and my size-

ten shoes, which should have been a size smaller. I tried to ignore her, but she was coming so forcefully at me when all of a sudden (it wasn't me) the Holy Ghost spoke to her and said, "Come to the worship session and you will see who you are laughing at."

The girl was so surprised and heady; she went and gathered a few of her friends to really see what was going to happen. I went for my book anyhow, but on my way coming over something powerful happened to me. My entire body started to transform from ordinary to extraordinary as I felt the living fire on my body so mighty that even my hands were closed. (This is real, my friend.). I walked slower and slower to see if it was my mind or feelings of anxiety, but know it was the anointing from above. As I got closer to the classroom, the Holy Ghost said, "Today will be Pentecost like never before." I went inside imbued by the Holy Ghost.

The president welcomed everyone and then handed over the service to me, inviting me to tell the students what the Lord did at 2:30 pm that day. The opening song I requested was, "Enter My Chambers, Be Free Holy Spirit." As we were singing the song, I glanced to my immediate left and saw the young lady that had been making fun of me. Anyway, I asked the members and visitors to stand as we closed our eyes and asked the Lord to enter into our chambers and take control. The Holy Ghost told me to lift my hands (closed) as a symbol of giving thanks to Him. Then I heard someone cry out like blind Bartemus: "Lord, Lord, help me."

The crying was so loud that it attracted my attention, but when I looked at the girl standing beside me, in all my life I have never seen this before. I saw the emblems of the Holy Ghost anointing on her. It was in two distinct forms: the form of lightning and the other took the form of a bright shining countenance on her face. She, I believe, was chastised and transformed from glory to glory. Moses' face was shining with the glory of God. I mean that girl's face was glowing as the glory of God came down and baptized us all. It did not stop there. As I opened my hands over her, I saw hail-like raindrops falling in the class on the students, and in seconds every student, even those at the door, was filled, touched, and baptized by the Holy Ghost. The power from on high visited us that day, all because we were obedient and available.

I witnessed this great outpouring in my life, my friend, and I believe that you today, even right now, can experience this outpouring of the

Holy Ghost in your life. Only be obedient and available. Isaiah's lips were touched by God with live coal from the altar. You can be touched also.

The anointing is summed up and experienced in different ways, but this one was divine and real. We were refreshed, revived, and restored. The young lady that very moment apologized to me, which I also did the same for pronouncing judgment on her—it was for a purpose. That day, many students got saved and until this day many are still serving and worshipping God in Spirit and truth. Although we are now apart in our different careers, we will never forget this great experience. Each time I remember, my heart burns within as I reflect and communicate with God.

Nineteen

Biblical Typology of the Anointing

But my horn shall be exalted like the horn of an unicorn;
I shall be anointed with fresh oil (Ps. 92:10).

There are different manifestations of the anointing unfolding in the Bible to prove to the world God's immutable powers and to confirm that He alone is God, and to confound the wise. Such illustrations can be seen in the following periscope:

📖 **The Manna from Heaven (Exodus 16:10–21).** This was a typology of the supernatural anointing given to the children of Israel each day to supply and nourish them for forty years. This manna was not the product of plant; rather it was angelic food from heaven (Ps. 78:25, John 6:31–32). It was sent divinely by God and not by Moses. They needed fresh manna for each day. This manna was a type of the anointing, because the manna provided previously was not suitable for the next day. So it is with the anointing: every new day, new task, and new ministry requires a fresh anointing.

ഓരു

The manna from above was a prototype of the Bread of Life to come, Jesus Christ.

ഓരു

📖 The manna from heaven was also a foreshadowing of The Bread of Life to come: Jesus Christ! In fact, manna in the Old Testament goes beyond spiritual food for the children of Israel in the wilderness. It represents Jesus Christ in eternity and also Christ in the flesh (incarnation). The manna before that that fell to the ground was the bread of life (See John 6:47–50.), then when fallen on the ground depicted the incarnation of Christ Jesus in the flesh. So in essence, the children of Israel were eating earthly food (See Exodus 16:14–15.) and spiritual food (See Matt. 4:4; John 6:36–35.). This is a deep

spiritual truth. Today, the manna is Christ, the Living Bread among us. What a wonderful revelation to start with, my friend. He is the Living Bread of Life. And the more you eat, the more you will have life and have it more abundantly. This *bread* will not give you sickness or wear your body out either. It will quicken your mortal body. This is the Living Bread. Feed on it! Believe it! Digest it! And you will have eternal life.

📖 **Elijah's Food (1 Kings 19:6–9).** Deep calleth unto deep, says the word of God (Ps. 42). And if you are not living in the spirit then it will be very difficult for you to understand the knowledge of God's power. Elijah was commanded by God to go to Cherith, by the brook, and there he would be sustained by the miracles of God. Going to the brook of Cherith, which means "isolation, place of cutting and cutting edges," was very vital in the process to prepare him for the battles ahead and the forty-day journey. Elijah was fed by an angel to sustain him for the journey he was to undertake. The word of God said that the angel told him to eat for the journey is great. Apparently, the man of God was discouraged, fearful, tired, and lacked strength for the angel to command him twice to eat. Nonetheless, the food that he ate was a type of the anointing, simply because a few days back he had prayed down fire and rain from heaven and ministered under a mighty anointing, which dismantled, defeated, and disgraced the prophets of Baal worshipers. (See 1 Kings 18:21–46) Their camps were left in disarray by the power of God through his manservant, Elijah.

The next day he was challenged by their chief in command, Jezebel, to kill him. The Bible says that Elijah fled for his life, and so he became discouraged when he heard about the summon Jezebel gave to have him beheaded. He went and hid himself, requesting death as the penalty from God. (See 1 Kings 19:1–15.) The spell of fear was cast at Elijah so as to silent the anointing of prophetic utterances on his life. It is obvious that the anointing on Mount Carmel had left him because of fear. As servants of God, we have to be keen to the wiles of the devil and don't play "strong in the rings of Jezebel or the barber shop of Deliah or at the party of Erodius." That is the time the enemy will attack. I once told one of my teacher friends that your strong point can be your weakest outlet to the predator. I also let people on a whole know this: the greater the anointing, the greater the intensity of the rise in your hormones.

Know Your Source of Authority

When you minister under the anointing, all your adrenaline increases to the point where your body becomes weak, tired, and cold Believe it or not, it is true. This is one of the factors why many mighty men of God fall after ministering under such anointing. The devil waits when you are weak, tired, placid, etc. to attack. It is possible for one to minister under a powerful anointing today and be empty the next day. This was the experience of Elijah and John the Baptist. They needed to be restored, refilled, and revived for the journey. And so it was at this crucial point of great restoration that the angel appeared unto the man of God and fed him, so that he might gain power (anointing) to continue his ministry.

This is indeed a lesson for young ministers with zeal and passion to be aware of. They should be desirous to know that in this world we battle against three contentious foes: flesh, world, and Satan. We cannot operate in the realm of flesh to undertake spiritual task without having the anointing to do so. We need the anointing with fresh endowment at each time, because the journey is so great. To do this, we should wait constantly on the Lord to fill our cups and let them overflow with fresh power.

The Rod of Aaron: God's Power

Aaron's rod is very symbolic when compared to the infallible attributes of God's magnificent power through various types in Scriptures. The Bible has strict illustrations on each account of *the rod* demonstrated in the Old and New testaments. The methods are different, but the principle behind each typology remains prophetic, never changing.

"The rod of Aaron," speaks divinely of God's power over satanic powers: In the account of Exodus 7:10–12, a glorious miracle contest was done to prove in battle whose power was greater than the other. It was a competition between two of sets nominees to prove whether or not the magicians' powers were greater than the power of God. It was a competition to see who would win the election—God's power or Lucifer's power, Moses or Pharaoh? The rod, in the hands of Aaron, the high priest, was endowed with power before it was placed on the ground. The Bible says Pharaoh wanted a miracle so God commanded Aaron to cast the rod down. God is miraculous, the creator of miracles, but Pharaoh is not; he is the counterfeit of miracles. Notice that Pharaoh's magicians counterfeit the rod of Aaron with the thought that he would have conquered, defeated, and swallowed his rod, but notice the greater power prevailed.

The rod of Aaron was and is still a symbol of God's power and authority denoting his choice of blessing on you (Aaron).

This single virtue of power exhibited against Pharaoh's magicians shows that only the genuine anointing will last. God did not double his power on them; this is to show us as believers that the omnipotent power that we have in Christ is greater than the world's power … "For greater is He that is in us than he that is in the world" (John 4:4).

The rod of Aaron was also a symbol of God's power and authority: in Numbers chapter 17, the true picture of the rod was revealed to Moses and the children of Israel. They were commanded by God to gather twelve rods from every tribe and place them in the tabernacle before the Lord. God's choice would be demonstrated to the one whose rod would bud, blossom, and bear fruit. In the morning, Moses would enter the tabernacle to see whose rod would bud and which rod God would choose. God's choice of blessing was manifested on Aaron's rod.

> ∞⟩⟨∞
>
> There are many ways the enemy can be exposed and defeated when we apply the power of Jesus with authority.
>
> ∞⟩⟨∞

The rod of Aaron was now God's new order of authority and power in the camp of Israel. It was placed in the tabernacle at all times denoting God's choice of blessing on Aaron as the one chosen to approach Him in the holy of holies. (See Psalm 65:4.) It was this same rod that the Lord told Moses to choose when the children of Israel needed water. (See Number 20:8.)

The power of God is so immutable that it speaks volumes of itself. Sometimes its manifestation calls for a sense of investigation on the matter, but when you think of his goodness and faithfulness and what he has done for us, our soul cries halleluiah! God is good, my friend, and as I said prior, things at times will baffle our minds about God's power, but when we get deeply intimate with God then you will understand.

His voice makes the difference. When he speaks, he relieves our troubled minds; it's the only voice that makes such a difference that I will follow it one day at a time. And so it is with the illustration of the rod of Aaron. The uniqueness of his choice among the different rods brought restoration to the camp of Israel. Aaron was a type of Christ. The Bible ascribes similar miraculous powers to the rod of Aaron and the staff of Moses. The staff which Jacob used to cross Jordan is identical with that which Judah gave to his daughter-in-law Tamar (Gen. 32:10, 38). It is likewise the holy rod which Moses, Aaron, and even David used to perform miracles and wonders before Pharaoh's magicians, Korah, and Goliath. When the messiah comes, it will be given to Him for a scepter in token of his authority over the heathen.

As Aaron was known for the rod he carried, so will Christ be known by his rod (Psalm 2:7–9; Revelation 19:15). For all power and authority belong to Him.

There are many ways the enemy can be exposed and put to total defeat when we apply the correct power with authority.

Thou Art the Christ!

That word means the Anointed One …

Jesus is the anointed one who destroys every yoke.

He is the son of the living God …

The Alpha and the Omega.

He is the Beginning and the End …

Who do men say that I am, and who do you say that I am?

It is time that you and the world know about Jesus who we serve.

He is Abel's sacrifice and Noah's rainbow …

He is Abraham's well and Jacob's ladder.

He is Isaiah's fig poultice and Hezekiah's sundial …

He is the Anointed One, the king of kings …

He is the wheel in the middle of the wheels.

He is the fourth man in the fire of your furnace …

He is the lamp stand in the tabernacle, shinning His glory on us.

Jesus Christ!

He is

Now your Master

Savior

Redeemer

Healer

Deliverer

Sanctifier

and

Provider.

He is who he says he is:

The Christ, The anointed One.

Twenty-One

A Rich Inheritance (Possession)

As the first born of the body of Christ, you have a rich inheritance, a double portion of the anointing that you did not pay for. From the lineage of Abraham to Christ and other great men and women of God who have gone before us, they have left a great legacy for us to continue. This anointing is available to all who believe; therefore, you have to do one thing: *go in and possess your possession.* What is this possession? It is the anointing.

This we see in the book of Deuteronomy when God instructed the children of Israel to go in the Promised Land and empowered them to drive out the giants. So the children of Israel did as God had commanded. This is powerful, my friend; the olive plant was a typology of the anointing. So there in the text the anointing was already waiting for them to take possession. There was anointing with provisions of God's resources waiting for them, which they did not harvest or plant but reaped. This must be God. In the same breath, I want you to know now you can reap what you did not sow. There is a double portion of the anointing waiting for you. Claim it now.

Fullness of the Anointing

There are different measures of the anointing (gifts). Every born-again believer has a measure of the Holy Ghost, but not everyone has the fullness or the extension of the Holy Ghost. This is called the baptism without measures. To receive this extension of the anointing, you have to seek, hunger, and thirst.

> "Blessed are they which do hunger and thirst after righteousness for they shall be filled" (St. Matthew 5:6).

It means that you shall be filled with the extensions of the Holy Ghost, such as speaking in tongues, prophesying, and healing. (See Ephesians 4:7.)

God wants to widen your horizon, vision, and images times two. He wants to do an enlargement in your life. In mathematics, I have learned about *enlargement* and the meaning of it is "to get the image bigger that the object." Your object can be anything. Your object can be a job, a car, a business, a home, a piece of land, or whatever you desire. God wants to use your image from your object and extend that desire, that goal, and that dream to a bigger and better one. As a matter of fact, the anointing that God is going to give you will be so powerful that it will increase each day immensely.

I believe in my spirit that God wants to open your eyes wider and clearer to his new plans for your life. God wants to do something bigger in you, through you, and around you—through his anointing. The best is yet to come for you in the name of Jesus. He wants to open your eyes to new revelations. Many people wear eye glasses simply to see better, but this revelation will require no eye glasses. The anointing on your life will anoint your eyes to see the things he has in store for you. Therefore, he will expand you to see clearly.

God is going to deposit all in your bank account. Your life may be empty, dry, and barren, but the good Lord as I write this book is going to place a certain amount in your account. This one will turn everything around. Have faith in God.

Twenty-Two

Exposing Demons with the Power of Love

The foundation of creation was called into being emotionally by God with love. The greatest and most renowned verse in the Bible is John 3:16—*love*. It is the greatest and most infallible weapon in all history of humanity. It is the pillar that holds and connects heaven and earth together. It is the channel through which God communicated to his son, Jesus Christ, and to us today. The never-ending attribute that will continue in "thy Kingdom come on earth as it is in heaven" is L-O-V-E.

ഇ⊙രു

Love conquers all. The greatest weapon when used efficiently is love.

ഇ⊙രു

Sin is a monster; it is no respecter of person. Its aim is to destroy us by possessing our flesh, creating a war within. Sin is an enemy that fights within. It is a battle being raged right now within you. If the Christian has to engage in the war against sin and principalities, we have to come to the conclusion that the weapons we need are not physical weapons, but that which must be utilized against spiritual warfare. Such fire power is called the fruit of the Spirit. Satan is the enemy of the church and sets himself against that which is designed to build up the body of Christ and also to produce the characteristics of Christ.

Love Conquers All

Most Christians have heard the saying "Love conquers all." It is used in various contexts, but when used in the Bible it is true and powerful.

The Bible says we are to conquer evil with good. Jesus indeed says even to love our enemies. (See John 14.) Love covers a multitude of sin. Indeed, love is the culmination of the commandment of God. The golden rule of Jesus Christ is love; do unto others as we want them to do to us. He who loves will obey the commandments of the Lord (John 15). The Bible distinctly says we cannot serve two masters; we will hate one and love the other. The fruit of the spirit as enumerated in Galatians 5 includes love, joy, peace, longsuffering, kindness gentleness, goodness, meekness, and temperance. These nine fruits represent the very nature of Christ. When the fruit of the Holy Spirit is produced in a believer's life, he identifies with Christ. Therefore, you will portray and display the same work and even greater works than Christ. Whenever you appear in churches where demon manifestations are great, the nature of Christ in you will reveal every evil spirit.

There is no fear in love; but perfect love casteth out fear: because fear hath torment. He that feareth is not made perfect in love (1 John 4:18).

The Bible is the story of God's love to mankind and how it triumphed over darkest evil. God showed the ultimate love through the gift of His Son for our redemption.

> But God commandeth his love toward us, in that, while we were yet sinners, Christ died for us (Romans 5:8).

> For God hath not given us the spirit of fear; but of power, and of love, and of a sound mind (2 Timothy 1:7).

> We loved Him, because He first loved us (1 John 4:19).

God is the author of love. In fact, His very nature is love. Fear cannot exist where genuine love is, especially in those who are filled with God's love. In a world full of fear, Christians need to share the love of God with others and let them know the love, hope, and salvation that is in Christ.[2]

Demons are opposite to the nature of Christ. They enter in a person in order to project their own evil nature in that person. That is why it is imperative after deliverance to cleanse the vessel with the fruit the of the spirit, mainly because the demon that is cast out leaves the vessel defiled

To discern, you cannot judge. We must first find the heart of God, which is love.

2 Joseph Hogrete, *Devotional Thought.*

and must be refilled with the fruit of the spirit, otherwise the evil spirit will come and take repossession to a greater extent than before.

Demons have to render powerless at the command and the authority of Jesus' name. Jesus used the analogy of the vine to demonstrate the importance of abiding in the vine and keeping the commandments.

> ... the prince of this world cometh, and hath nothing in
> me ... and as the Father gave me commandment, even so
> I do ..."(John 14:30–31).

The devil has no power outside of the border of God. He has to be completely obedient to the Father (God). This is why Jesus could say these words.

The true knowledge of love being used as a weapon used to conquer was revealed to me on a week of intense fasting with prayer as the deliverance team and I were up against "a garderene" (See Luke 8:26–39.) who was possessed for eight years. That person was very active in church and easily got *in the spirit.*

As I was seeking the Lord in depth for a revelation to conquer this *chief principal,* the Lord spoke to me in a simple phrase: "Jesus loves you—I conquer with love." Midway in the fasting, I called my standard-bearer and conveyed the revelation from the Lord. As a matter of fact, we both were contemplating on how to rebuke this demon. The following Sunday I went to church for the Sunday school service since I was the teacher for that session. I did not stay for the remaining service because a good pastor friend of mine asked me to minister at their church that day. However, after ministering at that church I left and returned to my church to contend with the manifestations that were taking place.

One thing I certainly know is that demons recognize authority and respect authority. The commotion ceased immediately as I entered the door. That day, I sat and worshiped beside the young lady who was possessed with the demons. As I sat beside her, I was praying, asking God for the strength and the perfect time to tackle the deliverance process. However, after all this, I was able to console the people of God and managed to invite them to attend evangelistic service. In the height of the praise and worship session while the anointing was ministering, I started to watch the woman for any signs of demonic attacks of the demon. As the anointing began to flow, I

started to see different levels of manifestations; I did not hesitate. I went over and did as the Lord had commanded me. I held the woman and looked into her eyes with the power of God and said, "Jesus loves Mrs. Dolly." I shouted, "I conquer you with the spirit love." The chief cried out like a lion, "You cannot conquer me." Then her eyes became glossy and dark like coal as I commanded the chief principal to go. It took the deliverance team the remainder of the service to renounce and restore the woman.

That night she got delivered and a few days later she vomit all the impurities that were inside her. Today the woman is happily worshipping God and enjoying a better family life with love.

The conclusion of the matter is the family was taken over by a spirit of "a colony of bitter spirits." Teachings were introduced to the family, the word of God was applied, and the basic principle on how to stay delivered was imparted. The fruit of the spirit was explicitly expressed by the members of the church, which helped in the process.

When operating in a deliverance ministry, you must possess the character to love. For eight years, this woman was bound in chains of unforgiveness. She attended church, but deep within her the spirit of unforgiveness abounded and was taking control over her life. Many persons around her could not discern the troubled state she was in; but as I watched her I noticed whenever she came to church the first thing she would do was to find the altar and cry out to God.

ഇ)ര

Unforgiveness is a spirit that diverts the mind from the joy in Christ.

ഇ)ര

After she prayed, I also realized that she walked around and hugged the members, expressing her heart's desire even though bound on the inside.

True Discernment Is Wrapped up in Love

According to France Frangipance, "Abounding love brings discernment with it."

This is true. The moment I started to show her the love of Christ, I realized there was a change in her attitude and her worship became more meaningful. From then on, I became a spiritual mentor to her.

Whenever you are in a church or around fellow Christians, you should be able to detect true love because all love is pure and genuine and knows no other actions but love.

- False discernment is a result of lack of love for the individual, whether social, romantic, or spiritual.

- Godly discernment is pure with godly motives that is rooted in love.

When we are accustomed to someone who we know is under spiritual attack, we are quick to judge or to come to our own conclusions rather than going to God in love and praying for the spirit of love to discern what steps to take when confronted. Too many times, we make false judgments by just looking on the outward appearance. This woman, although she was in that predicament, was a worshiper. *To discern, you cannot judge. We must first find the heart of God, which is love.*

The root of godly discernment is love with pure motives, while every false discernment is a result of lack of love.

Twenty-Three

The Purpose of Man

Before anything else was, God is. The word *God* denotes "self-existing one, or self-sufficient one." Therefore, God is not a name but rather a description of a character. This independent God existed before all things and began His own creative work by first producing the entire invisible world, which we have come to know as the *supera* natural world. What a mighty God!

All of this is summarized in one word: *purpose*. Out of this purpose generates His characteristics—love. Yes! We may want to be presumptuous by asking why the king of heaven would want to create (sons) spiritual children in his image and a visible universe. It comes right back to His character, love (1 John 4:8–16). Note wisely that He does not say He *has* love but He *is* love. This is an important distinction when it comes to understanding His purpose, because if God is love, then his complete being and actions would naturally be the manifestation of the nature of love. He sent His son, Jesus Christ, in the world to die for our sins, all because of love. He went to the cross and was resurrected just because he loves us. Love says the Bible covers a multitude of sins. The opposite of love is hatred, which is iniquity and was found in the "anointed cherub." Therefore, the father of love is God, and the father of hatred or iniquity is the devil. God creates love! The devil creates iniquity. To overcome the battles of hatred, guilt, jealousy, and intimidation is to share and spread love. Love conquers all.

The devil is afraid of the power of love. That is why so many churches focus on religion rather than kingdom building. The instigator has sown

> God is not a name but rather a description of a character.

seeds among the believers, wheat against thorn, and competition among compatibility. As I have shared in the previous chapter, we have to know the wiles of the devil. They are very cunning and divisive, but the anointing always exposes his deeds, sooner or later. If the body of Christ can unite and come together in love, then there would be no church splitting and contention in the body of Christ.

Now since God's very nature is love, love is something that you share rather than keep. Ah! If this be so, then the very nature of God would be the desire to share His kingship and domain. In essence, love is fulfilled when it is seen, gives, and shares itself. Through this inherent nature of love, He was motivated to create mankind to share His kingdom and kingship. The kingdom was provided for man. The Messiah said these words in Matthew 25:34.

> Then the king will say to those on His right, Come, you who are blessed by My Father; take your inheritance, the kingdom prepared for you since the creation of the world.

Disobedience Can Ruin Our Position and Purpose with God

Man was created with the gifts and divine nature to execute God's will in the earth. God's purpose was to have His will done and the heavenly kingdom come on earth just as it is in heaven. Man became disobedient to God and obedient to the wiles of the devil. The innate nature to sin was then incumbent on the choices we make in life that will guarantee everlasting life.

Later on, you will find out this dilemma. When God created man, please note that the first thing He gave him was his image and likeness, but the first mandate and assignment was dominion. His purpose was to represent God on earth—his kingdom; and his position was to manage, supervise, and rule earth. There were specific mandates given to man, such as dominion over earth and dominion over creation, but not man. He gave man a relationship, not a religion.

He was serving as heaven's earthly ambassador, so his ambassadorship also represents his relationship. His relationship with God was communicated by the Holy Spirit displaying the bond and intimacy

mankind had with the Holy Spirit and God. Since the Holy Spirit was the most important person on earth to mankind, He is a key component of the kingdom of heaven on earth today, which qualifies and equips mighty men with power and authority. If the Holy Spirit is taken out of the world, then our connection with God would be lost. We would not have that right knowledge of who God is and would not know the mind of God. This was what happened to mankind. The loss or separation of man from the Holy Spirit of God would render mankind a disqualified envoy of heaven on earth, for he would not know the will and mind of God in heaven or on earth. He would now be exposed to good and evil.

The record of God, a disappointing scene of mankind with the adversary, the devil, in chapter 3 of Genesis, was designed to drive man from the garden of relationship, from the presence of fellowshipping with God and heaven. Could mankind be redeemed? Oh, yes! With what? The precious blood of the Lamb—oh, praise the Lord.

God knew all of this predicament would in no wise be altered by the devil. Looking back on Genesis 1:26, scholars like Myles Munroe rightly declare, "Two of the most important words ever spoken by the creator are locked away in this verse." It is a Christmas gift neatly wrapped in special papers just waiting to be given and exposed. (It's a secret!) Those words are *"let them."* By these words, the creator established a law that only gives mankind the legal authority to exercise dominion and control over earth. Just as in Matthew 16, legal authority using the name of Jesus is the only source to deliverance. It is very profound to note that God did not say *"let us"* but rather *"let them."*

In the case again with Lazarus, Jesus could have said, "Dead, come forth," but He called him by his name saying, "Lazarus, I call you, come forth in the name of Jesus." What you don't know would definitely destroy you, but what you know will guide your thoughts. It is not what we can see, but who is watching us. God is all powerful and all knowing and so he used a paradox this instance. He never involved them and not us in His initial redemption for mankind in heaven, but only on earth and this is for a prime reason. The Bible says, "When the fullness of time was come; God sent forth His Son born of a woman, made under the law" (Gal 4:4).

Do you see the big picture? Jesus said to his mother at the wedding at Cana, "Woman, what have I to do with thee? Mine hour is not yet come"

(John 2:4). Jesus was simply saying, "I am waiting on My Father to give me the go ahead. My hour for working miracles is not yet come." The operative word then is to *wait*. I believe Jesus was saying to them, "When it is my time you will know because I will be well prepared." The next operative word also is *prepare*. What God is saying is *waiting takes preparation* and *preparation brings results*. You cannot sit an exam without any form of preparation, whether it is mentally of physically.

God did His final exam, his final showcase, masterpiece, and his final PhD. He came to his final plan! Now it is time to reveal the revelation. JESUS. "Who do men say that I am? The Prophet, Elijah, and or John the Baptist." Only one person caught the vision: Peter, the denier. It was a shock to many, an alarm: Thou Art the Christ the Living God. Divine revelation comes from the Spirit of God and not from flesh and blood.

Throughout the Old Testament to the Inter-Testament to the New Testament Period, God had a plan. A seed!

The Original Plan

The time has come! If He had said *"Let us,"* He would have provided access by Himself to earth anytime without violating His word and thus be co-ruler with man. (He would only have dominion on earth rather than in heaven.) God would expose his master plan. You see God cannot abort his purpose by exposing his true identity or everything at one time. That is why He is God and God alone; He has some reserves for you and me to show how magnificent His majesty and glory are. In Matthew 5:18, Jesus says, Not a jot of His word will pass. God was the prophecy. The Bible says God will not share his glory; therefore, we are no match to God's wisdom, power, and might. He cannot be our co-ruler! He is not for that purpose; instead, he is the ruler; the king of kings, the lord of lords, and the wheel in the middle of the wheel. He is the ruler and not the co-ruler. So by stating, *"let them,"* He is preparing Himself a body fashioned with the blood of His only begotten son (John 3:16). Myles Munroe said, "by stating 'let them,'[3] He locked himself out of the earth as a spirit being

Throughout the Old Testament to the Inter-Testament to the New Testament period, God had a plan. A seed!

3 *Rediscovering the Kingdom.*

without a body." He locked himself out of the equation of earth (the flesh) into the heaven (the spirit) talking with His Son, Jesus Christ.

Habakkuk reminds us of God's law whenever He speaks. God said in verse 11 of Isaiah 55, "My word will not return unto me void but it shall accomplish what it set out to do." The *word* here is Jesus Christ incarnate. John vividly stated in the beginning was the word, and the word was God, and the word became flesh and dwells with us. Jesus is the word to accomplish the master plan for God. Since God is a Spirit, and when He speaks His words become law, His integrity would be put to the test. So He has to maintain his principles. God could replace man with thousands of angels after his fall (Adam), but his integrity would not allow Him to violate His word. This is to show us on earth how important man is to God. We are his source of access on the earth—His agency!

Bound, but not confused by His own law, He had a plan worked out from the beginning. He would now introduce His own son into the human equation by the power of incarnation. Since Lucifer and Mankind failed through His son, God could accomplish his will. Through this seed, the serpent head would be crushed and his heel bruised. Through His son Jesus Christ, man would be redeemed by the shedding of His blood. Through Jesus, the devil's deeds would be exposed and brought yet another victory to the Lord God. The redemption process will continue because mankind is won back to God.

Now it is necessary for us to know this: God came in the form of Jesus and now through the indwelling of the Holy Spirit

Twenty-Four

Where Is the Anointing in the Church?

Is It the Anointing or the Appointing—Which One?

Moses and Aaron, when confronted with Pharaoh and his confederates to release God's people, engage in a contest to determine who possessing power is stronger: God or Pharaoh! The power of witchcraft is powerless to the power of God. The rod of Moses swallowed all the serpents of the Egyptians (Ex. 7:10–12, 22; 8:8). This shows that the true anointing is stronger and more powerful than any satanic power; for greater is He that is in us than he that is in the world (John 4:4). The magician said to Pharaoh, "This is the finger of God." The magicians admitted the mighty power of God, working through Moses, was greater than theirs. God anointed the rod of Moses while Pharaoh commanded his magicians by way of appointment of his council, to select these men of seemingly great men to contest with the divine God.

Now the magicians so worked with their enhancements to bring forth lice, but they could not. So there were lice on man and beast. Then the magician said to Pharaoh, "This is the finger (anointing) of God." (Exodus 8:18–19). The anointing will expose the deeds of anyone who wants to ascribe titles to himself for recognition. From this point on, the magicians are not mentioned again. They were no longer able to duplicate the plague God sent. You cannot stop the anointing, but you can stop the appointing.

Elijah versus Baal was another great contest. The prophet of Baal was asked to called on their gods and for hours they were there shouting and cutting themselves with swords with no results. But when Elijah called on the true God of Israel, things were different. The anointing makes the difference. You cannot expose God; He will dispose you to shame

especially when you are to be like gods. One of God's distinct commands is you shall have no other God except me. No graven image!

The Baal prophets were known for worshipping other gods. It was a ritual and custom in those days to do as the family does. But this day will history record itself on Mount Carmel. The true God did manifest His attributes in the likeness of fire. From that day henceforth the people fell on their faces saying, "The Lord, He is God! The Lord, He is God."

The devil knew that Jesus already defeated him and won the war. But in every war, there are some battles that will be won by the opposition just like politics. Since there are a few battles left to be won, the devil will do everything in his limited power to conquer all, and so his attack on the body of Christ will be different. He is using the appointing and not the anointing. The spirit of legalism—I am free to have my own church, the power to go wherever. But I have news for every preacher with this behavior: you need a covering of the anointing and not the appointing.

Open your eyes in the name of Jesus Christ. The devil is bringing weapons of mass destruction in the body of Christ in the form of manipulation, intimidation, and domination. The pulpit spirit of Jezebel! The pride spirit of Lucifer! The anointing says the songwriter "will break the yokes." It is not by our might but by the anointing. The more devices the devil comes with, the greater and more powerful the anointing will be. As a factual matter, it will increase.

Not everything we can accept in the temple of God. I used the word *temple* simply because we are the "Temple of the Holy Spirit" and whatever invades the house of God automatically transfers on us. Not everything we must be quick to say yes to. The Bible says we must at all times try the spirit with the anointing. Too often Lucifer comes in the church presumptuously and we play blind to his domination. Where is the watchdog in Zion? If we are going to get radial, we better start from now and stop playing church. The devil is having a jolly time whenever he sees chaos in the body of Christ.

Whatever comes in the church will automatically affect the body, unless the antibodies are stronger than the antigen the body is producing. The apostle Paul had this problem in Galatia—bewitchment—people that have tasted of the living water and experience the power of Pentecost. The Galatians' saints had the gifts of the Holy Spirit, but they were novice to the moves of God and arrogant to the powers of bewitchment.

Did you know that a church can be filled with good Spirit-filled people and yet be foolish to the movement of God in their midst? They can hear an anointed word from the heart of God but remain unable to respond—it is a spell. Many of the modern churches in Galatia had a history of bewitchment. There was an incident at church where we were asked to pray for a month, no preaching. Seemed foolish! We carried out the order, which was a struggle for believers. The very start of the service, was like lighting a "coal skill" (lukewarm) the church was infested with "smoke." (hyprocrocy) Service was like lead sulphate. The church was misled by those in authority. All I did was heed the command to pray.

ഇൗരു

Bewitchment is the power to mislead, using spells.

ഇൗരു

Bewitchment is the power to mislead, using spells. The damsel possessed with demonic spirit at Philippi was able to prophesy although she was a true prophetess of God. She was under a spell, a lying spirit from Simeon the sorcerer who later was rebuked by Paul who had the true anointing. I have heard many moderators say the service is "tough," or "I can't feel the believers." When in fact it is the power of bewitchment cast in the service. Such cases require the genuine anointing to discern and cast out every lying spirit in the church. This same Simeon, the sorcerer, succeeded in deceiving Philip. He pretended to have been saved and was baptized. He even was on the board of evangelism in Philip's ministry, until he was discerned and sternly rebuked by Peter (Acts 8:9–11; 12–24).

Every born-again believer should have the spirit of discernment to guide and lead him or her in all areas of life, both secular and spiritual. Remember, he is *Beelzebub,* father of lies, and his aim is to deceive as many before his final doom. Don't be carried away by the wind of doctrine that blows their way; some of it is dandelion spirit of witchcraft. I say this to the church: I pastor, I am not moved or strengthened by your level of knowledge and education of speech in any setting at church. Sooner or later, you will be like the chaff that the wind blows away all because of the anointing (Ps. 1). What I am affected by is the spirit that is using your ways and not you personally.

It is full time for the church to use the power of discernment and not the power of supposition and assumption because these spirits are vicious. It is not time to play with fire in the body of Christ; it will burn you. We have to get real; the truth is the truth; the mystery of iniquity is right under

our nose. Can you smell the odor? The devil comes with nothing good. Just like a K-9 dog specially trained to monitor any situation come his way, so should the church be at all times—shifting and tracing every foul spirit of the devil from building a barricade around the Christian perimeter. I feel the power of the Holy Ghost as I write under the inspiration of the Lord, the demon of legions, insanity and Achan is at work in the church, school, marriage, business, and family.

He listens to every word that you are about to speak but in the name of Jesus. I speak to all forces of darkness that are encumbering your mind right now in the name of Jesus. You will be free today, this very moment, for the greatest miracle is about to be revealed and will bring changes in your life, spiritually and physically. The demon that has been plaguing your mind and soul is destroyed by the anointing of our master, Jesus Christ.

I know that I am talking to someone right now. These words are for you. The fight is on, oh Christian solider, but you have come too far. You can't turn back now because you are at the brink of your greatest achievement in history. You are at your very best!

The Power of agreement lies within your spirit.

Don't be fooled by the lies of manipulation and intimidation of the evil one. It is over! This is the beginning of miracles for you. Receive it in the name of Jesus.

Prayer of Agreement

Father in the name of Jesus Christ, your true and living Son, I come in agreement with the power of the Lord Jesus against every demon of warfare, psychological attacks on marriages, spirit of poverty, and Jezebel spirit. I stand completely in the name of Jesus, the blood of Jesus, and the word of Jesus. I now stand with the consent of the power of Jesus given to me to rebuke, renounce, and decree total victory over every area of your life. Amen.

The spirit of God says I must tell you to agree with me in the spirit for every door to be opened over your life. I may not be present with you

bodily, but the Holy Spirit is there with you right now to bring deliverance in your life. "For where two or three are gathered together in my name, there am I in the midst" (Matt. 18:20). God is in your midst right now to give you the expected end that you have been longing for.

The power of agreement lies within your mind and spirit with one purpose. The flow of God's anointing will start once you achieve this mutual agreement. The word *agree* is derived from the Greek word *sumpheneo*, which literally means "to sound together." That is to be in one accord, to harmonize as in music and to flow together. On the day of Pentecost, the Holy Spirit fell upon them, because their request demanded an urgent divine intervention. We are told that "they were all (still praying) with one accord in one place" (Acts 2:1). This caused a mighty earthquake of revival on the city of Jerusalem that day. Those who don't understand the anointing will tend to make judgments and criticize. As in the case at Pentecost, they thought the disciples were drunk, but in truth they were drunk and soaked in the power of the Holy Ghost so the demonstration seemed foolish, but God was in every move of the manifestation. Peter under the power of God got up and declared the power of the Lord. Some were convicted while others went their way.

Strange Fire with the Anointing in the Pulpit

And Nadab and Abihu, the son of Aaron, took either of them his censer, and put fire therein, and put fire incense there on … (Leviticus 10: 1–3).

We are only deceiving ourselves when we allow the devil to have his full course in the church and family. The young priest knew the fundamental principles on which God stands and the law of sacrifice (Leviticus 27) he required. They offered strange fires before the holy God. The word of God reminds us of this; God will not share his glory with any man.

This Is the Finger of God (The Fivefold Ministry)

And he gave some apostles, prophets, evangelists, pastors, and teachers for the perfecting of the saints. The anointing through the gifts of the church is for three designated purposes: edification, exhortation, and encouragement (building). In the discourse of Moses and Pharaoh, God

had to show Israel his purpose in demonstrating to Pharaoh who He really was.

The anointing comes through the channel of edification so as to bring consolation of the omnipotence of God who reigns supremely in awe. The finger of God was the fivefold ministry in operation against that of the magicians. Each of God's fingers has a responsibility with different functions. Pharaoh and his cohorts tried every other power they had and he was null to the power of God. The fivefold ministry is given to the church to counteract the forces of darkness, pride, false prophesy, divinations, and the misuse of the gifts.

Twenty-Five

Spiritual Witchcraft

The Spirit of Manipulation: Jezebel and Lucifer

Unless strong leadership is in place, a single person can render a church defenseless and powerless—even in spirit-filled church. The body is a prototype of the church. The body is made up of cells, tissues, organs, and systems. What gives and keeps each one of these cells is the blood. The blood unites the body through designated functions of each cell. Without blood, the body will be dead. The church in essence is bonded and connected through the blood of Jesus. The same way the body is delicate, so is the church. Everything passes through the blood to get to each cell. The blood transports and manufactures food to the blood and exports waste from the body. The blood of Jesus, on the other hand, washes and cleanses us from sin. Therefore, it means that the body, physically and spiritually, has to be at its full potential guarding against incoming bacteria (diseases). The blood has a role to play.

Back in school, we were told in biology class that a female can have more male hormones at times, which will determine the behavior of such person genetically. I have proven it to be not so true and so true. Yes, different classes of excess dominance can be seen in the genes of both male and female, but when it comes to a girl-boy and a boy-girl chromatin gene to totally distort human theology to something else. It was hard to swallow in that classroom, nevertheless, I took my notes wisely. There are some things in life that you personally will not understand until you surrender to Jesus Christ. My years at that school were a blessing and a challenge in that I have never seen demons like that before. Demons populated the teaching staff and some of the children. I could not stay in class for even fifteen minutes and was always called to rebuke demons of witchcraft.

How could this be? In school? Yes, believe it or not. From that day forward I was named "ghost buster" and was more popular among the girls of the top. I did not know that the spirit of Jezebel and Lucifer were at work while I was having a good time socializing with these school girls. These girls wanted to take me home to pray for their families and then to spend the night. I was terrified then and was challenged. I felt so weak and was attracted to every elusive and divisive method of those girls. To the extreme,

> ೲೃಀ
>
> Attraction is not anointing, but anointing can open doors of attraction for action to active with relationships and leadership.
>
> ೲೃಀ

I started to reflect on what I should do. I was trapped by these beautiful girls. Even at lunchtime, first thing they would come in my class and mince with wanton eyes and neck to get my attention (Isaiah 3:16). Those girls would even go as far as showing me their upper leg with tattoo designs. At one point, they had me prepare my things and I was ready to go over with the olive oil to pray with them. As God would have it on that the day of preparation, one of the girls called reporting that her mom was sick and instructed that I could either come to her mom's home then or wait until

another day. I never hesitated and reassured her that I would wait. I was delivered from the snare of the devil.

I write this to say that the spirit of Jezebel is out there wandering around, looking for available and idle vessels to use. I could be easily deceived. The anointing attracts all sorts of people, but you have to be on the double watch to guard yourself from being a victim.

Attraction is not anointing, but anointing can open doors of attraction for action to be active with relationships. This was what was going to befall me—the beauty and the attraction of these girls. Note well that I am not against beauty and attraction, but the fact remains the same: people are attracted to you for the wrong reasons and purposes. There is a motive behind every decision/action. My bishop dad at first was overprotective of me fellowshipping and associating myself with church sisters, but I could not see what Dad was seeing. My great-grandmother normally said, "What sweet nanny goat ago run him belly." These girls were so carried away by the spirit of Jezebel. I was being used by God to prophesy words of warning to His people and to heal the sick—fighting spiritual warfare. My dad was preparing me for ministry and the devil was manipulating me through beautiful girls. I could remember many nights I had to fight

physically to maintain my sanity in the Lord. I had to be a Joseph fleeing for my life. Yes! I was exposed before my spiritual father took me over and the gene for sexual pleasure was still there.

I had to thoroughly make a sacrificial consecration before the Lord. It was not easy. When the devil sees purpose in you, he will endeavor to stop and bring all the pleasure of this world to your attention. Jesus, when He was finished, fasted and prayed for forty days, had an encounter with the devil who presented all the fame and beauty of the world (Matthew 4). Jesus rebuked him with the word. You, my brothers and sisters that are today suffering from the plight of your past, can conquer such fear with the word, the blood, and the name of Jesus.

The Cross is where Jesus defeated the devil forever and forever, Amen.

The force of darkness was at work in my life. I was like Peter—prayed for and restored with the blood of Jesus. I became mightier, stronger, and more anointed with the power and authority of God. When Jesus was crucified, the devil thought that he won the war, but while he was rejoicing, Jesus was redeeming and restoring the keys of death and hell to His father.

The cross is where Jesus defeated the devil. I had to bear and carry my cross not knowing that the power of the cross is the life of the believer. The power of the cross has been free from the power of the devil. So what the devil meant for evil God meant for good. The first benefits of the cross in the life of the believer are deliverance from the law. I was delivered from the yoke and bondage of sin, oppression, and witchcraft.

At the age of nineteen, I had an encounter with "a lodge demon" who at midnight attacked the owner's daughter. Never acquainted with these manifestations, I was surely afraid when evening was approaching because I knew that it was soon time for the demon to attack the young lady. How could a blood-father sacrifice his daughter to such a witchcraft sect? At night, the lady would foam through her mouth, roll off the bed with moon eyes as if she was seeing someone else. (See Mark 9 and Luke 4:35.) I normally looked through the curtain to see the devilish manifestation. Sometimes I was asked to assist with the lifting of the lady back on the bed.

For months, this attack had been taking place to the point she was brought to the overseer's home and church for prayer, but she remained the same—until one day when I decided to pray and fast for the power of God to rebuke this demon. I remember having a week of prayer where I was baptized with the Holy Spirit, followed with a mighty revival at school.

My life was totally transformed and renewed by this outpouring of the rain from heaven. As a result of this manifestation that transpired, my hand would normally have a burning sensation that at times would even cause my hand to be closed whenever the anointing was so tangible and contagious. There was just a difference about me. My persona and voice changed when the Spirit of God moved upon me. As a result of this power, there was a desire for more of God, so I prayed and fasted for weeks while going to school to the point where the anointing was seen like electricity on the students and on my life.

Many times, I could not go to school because of the anointing and the closing of my hands—no one would believe the signs and wonders, but I could recall having a friend who always understand and stood beside me. No matter what, I could always count on him.

One night however, while coming from church, the spirit of God told me to prepare myself for spiritual warfare. As I walked through those doors, I could feel and sense the demon in the lady's room, so I went to see if she was okay. In all my life reading the Bible, I never knew that a demon could come in the form of a *crocodile* (Psalm 104). The demon transformed himself into a crocodile on the bed, flapping his tail. I locked myself in my room and started to pray with authority. As I was there, the only thing I could say was *the blood of Jesus.* The host of demons came down, but thanks to God who anointed David to pen Psalms 46: "God is our refuge and strength, a very present help in the time of trouble." I wrestled with the power of demons until the battle was won through the name of Jesus. For the remainder of the night, my hands were closed and I stayed out in the hall because I was not led to go back to my room.

It was about midnight while I watched and kept on praying because I was a stranger to this kind of warfare. As I sat in the hall, I heard the voice of God whisper in my ears, "Go home for tomorrow the demons are coming with a host of principalities." I was terrified for the God that I

serve declared in His words that he has not given us the "spirit of fear, but of power, love, and sound mind."

I hummed songs and prayers for comfort. Then I heard yonder one of my evangelist prayer partners started to say, "The blood of Jesus! The Blood of Jesus!" I mean the voice was so far, but the good thing was the sound of the voice was like a mighty rushing stream—a trumpet (Revelation 1:10). I looked around, but I saw nothing. As I started to sing again, the voice echoed this time in my ear louder and louder. My friend, the voice was like thunder; it was cracking and breaking some stuff around me. I mean the closer the voice came, the more and more things were just disappearing. Every stronghold, mountain, wall, and demon was utterly destroyed.

The voice was so powerful! It was like a trumpet sounding around the world (see the book of Revelation). Then I shouted, "The blood of Jesus!" That night, as the voice came closer and closer, I felt the blood like droplets of rain on my forehead and it ran down my face. (See Ps. 133.) I took my hand and swiped the dew over my face when I heard the same voice speak directly to my spirit saying, "Go home in the morning and don't say a word to anyone." I did as the voice commanded; this was the Saturday morning. I went home and my dad (spiritual bishop) prayed for me, but then I could still feel the spirit of witchcraft watching me, which I said to my dad, but he encouraged me to get some rest. While I was sleeping, the Lord took me in a vision to the same house where we went to pray and the lady dabbling in witchcraft transformed into a bat and attacked me, trying to let me know that I was the one standing in her way.

On Sunday morning, I went to church still feeling the eyes of evil watching me. Service was excellent. The pastor asked me to share my testimony, which I did, but something happened so powerful that I could not imagine. There was this young man who the Lord used to speak concerning my purpose and calling, and the same manifestation that transpired was confirmed in the service of the Lord.

God said, according to the manifestation of the Holy Spirit, "I have placed a mark on you (forehead) for ministry to be my own and I have called you for my vineyard." The bishop was to prepare and mentor me for ministry and not secular work. And I must stay on the pinnacle of prayer and then surely goodness and mercy shall follow me. That was a day of supernatural power as I was elevated to another level in God.

Today I am a living testimony to many, miraculously delivered out of the paws and powers of witchcraft, and I am still holding forth the good profession of faith, declaring thus saith the Lord. I was divinely covered in the Psalm 23.

> The Lord is My Shepherd, I shall not want. He makes me to lie down in green pastures, he restores my soul. He leadeth me in the path of righteousness for his name sake, yea, though I walk in the valley of the shadow of death, I will fear nor evil for thou art with me. Thou prepared a table before me in the presence of my enemies, thou anointest my head with oil; my cup runs over. Surely goodness and mercy shall follow me all the days of my life and I will dwell in the house of the Lord forever.

Twenty-Six

The Spirit of Idleness: King David

An idle Christian is a simple prey in the hands of its predators. Such a person is a dangerous tool in the hands of the enemy. We are up against the most dangerous creature in human history that seeks to destroy every living creature. His aim is to steal, kill, and destroy as many innocent lives so as to create his own army. (See John 10:10.)

The Blood of Jesus

One night at about 1:30 AM in the morning, I heard a voice echoing like thunder as previously experienced. The Bible speaks about the voice of the archangel that will sound and the dead in Christ will rise first (2 Corinthians 15). This voice I heard was the voice of Jesus. All surrounding darkness and forces were dispelled because of the power of the voice. The Bible says at the name of Jesus, every knee shall bow and confess that he is Lord. Demons fear the name of Jesus.

The Bible says that we are sealed with the Holy Spirit of promise (Ephesians1:13). The Bible also says when He sees the blood, He will pass over you (Exodus 12:13). Blood in the Old Testament was very significant in sacrifice, covering, vow, covenant, and protection. (See Exodus 24.)

Only the blood of Jesus could expose the hidden agenda of Lucifer. Each pathogen injected in the blood was always combated by the blood of Jesus so as to accomplish the sole purpose of the coming Messiah. The blood is a *microscopic investigator*—every examination is done through the blood; by this function of the blood it, identifies the harmful effect of the different cells.

The spirit of Jezebel is primarily attracted to the prophetic personalities, while the Lucifer spirit is attracted to charismatic groups, Pentecostal and evangelical churches. The characteristics of Jezebel are more seen in the female line, the latter in males. Lucifer's character is exhibited in males.

The Jezebel and Lucifer spirit is very hard to detect in the first stage. The reason for this is when such person appears in the church, we are normally excited and enthused to hear that individual preach, teach, sing, and even be a sub-officer. We are carried away by every wind of doctrine that's seemingly real. (See 2 Timothy 4.) They seem to have every vision and solution for the problem. They are the mouth, the speaker in the church. They can't keep still. They tend to have high levels of potential to serve and the anointing of compassion for ministry, but as soon as you start to pray in the spirit, you will be amazed what is hidden behind that personality: lies, rebellion, anger, arrogance, jealousy, cunning, craftiness, rumor-speaking, and manipulation.

The key to discernment is prayer. Whenever these persons come in the church, the service gets lengthy and the atmosphere is completely changed. We cannot take these Lucifer and Jezebel spirits lightly. Their mission is to pollute the body of Christ. Prayer is the most powerful weapon given to the church to communicate with God, but also to fight spiritual warfare. The depth and height of God is revealed in prayer. When you kneel and travail in prayer, the answer will be given.

In Revelation 2, Jezebel called herself a prophetess. A prophetess is one who speaks things into being as if they were, one that hears from God and delivers divinely, not falsely. The role of Jezebel is clearly seen here: a seducer and enticer. She seduced the servants to fornicate and to partake food for idols. What true prophetess would do that? Only a witch! Many church leaders and members have succumbed to the snare of adultery and fornication. This spirit has wrecked many lives, homes, marriages, and churches. Mighty men of God always fall into this temptress spirit. The remedy is to pray, burn the mid night lamp of prayer, and guard yourself with wisdom, knowledge, and understanding.

The spirit of Jezebel is attracted to counseling, especially when sessions are conducted by a sole counselor in an office. As a counselor, we were told at Bible college to normally counsel in an open environment, such as in the church, or if in the church's office to always leave the door partly open.

This might be strange, but be wise in what you do—the spirit of God will not always tarry with man because we are flesh. Counseling attracts this form of attraction with the wrong and good motive, therefore soberness and vigilance have to be at the forefront of counseling.

And since the tact of the enemy is so eminent, we have to counterattack the minefield of the devil with proper weapons and ammunitions, as stated in Ephesians 6.

ജ‍ഇ

Part 2

The Spirit of Jezebel and Ahab

ജ‍ഇ

Twenty-Seven

Dealing with the Spirit of Jezebel

Recognizing Jezebel

We are living in an age of corruption. The world today has turned its backs on God. Sin has rampantly infested the mystical body of Christ and its leaders. The voices of the prophets and prophetesses are being silenced; the flow of prophetic utterances in the churches has been chronicled by demonic influences and lives have been deteriorated by mortal combat of different strongholds that stage programs contrary to the operation of the Holy Spirit. This is designed by God, the almighty himself, to fight strongly and powerfully against any foreign *antibodies* that will create any potential harm to the standard of God. In all of this, the spirit of God is in total control of the main computer room with all access to clamp down on any spiritual virus that wants to attack the kingdom of God, and since our master knows exactly what his kingdom is up against, He co-joins and collaborates us with the parakeet (Holy Spirit) to enhance us with all the needed ammunitions to face every fiery darts of the enemy. Therefore, every stronghold established in Lucifer's mind and parameters will certainly be bombarded by the all-powerful holy one of Israel.

In the midst of chaos, confusion, and contention, God is still reassuring His people by comforting and consoling them, by raising a new battalion of warriors who will take the battle to the enemy's camp and burn it down. These soldiers have the militant mindset: mantle of Elijah's anointing, strength of Samson's anointing, and the courage and boldness of David to face and conquer any Goliaths that stand in the way and the will of the Lord. These warriors carry the mark of prophetic utterances to dismantle and dethrone every Jezebel spirit that has taken precedent in the present-day church.

However, while the Lord is recruiting mighty men of valor, the devil in conjunction with Jezebel is joining forces with Ephesians Six as a means of launching a counterattack on the body of Christ. Therefore, it's my prayer that as you read more into this book of revelation that you will be sufficiently armored with God's anointing to battle these cultic forces— in your sleep, at work, and even in your family. Believe it, my friend—the spirit of Jezebel is vicious.

The name *Jezebel* is derived from the root word in the Greek to denote *Phoenician* in origin and means "un-husband." It is very important for us to distinguish the name from the Jezebel spirit so that you can identify its network whenever it is germinated. According to John Paul Jackson[4], author of *Unmasking the Jezebel Spirit,* the name *Jezebel* as a diabolical spiritual force that seeks to deceive, defile, and destroy God's authorities. While his definition for the term *Jezebel spirit* is "a celestial power that has worldwide influence," it is simply a demonic power in the heavenly realm that transcends specific geographical boundaries and affects nations.

ഇൻൿ

Jezebel is a diabolical spiritual force that seeks to deceive, defile, and destroy God's authorities.

ഇൻൿ

In my intense mediation on the subject, the Holy Spirit revealed this to me. The name *Jezebel* is a counterfeit (demonic) force that has two facial expressions with the aim to deceive, dissuade, dominate, and defile the holiness of God; having no profile, respect or regard for protocol. The name also means "to chaste which bears the mark of bullies ready to fight." While on the other side, the transferring forces of the term speaks of "an expression is a result of your association," it is a wind force that targets the circle of nobility with the spirit of pride. It is a force of iniquity and pride to reckon with that spreads like wildfire, breaking out increasingly in the atmosphere in relation to catastrophes. It is also a prideful spirit that develops slowly, but controls after. It is interesting for you to understand the chemistry behind this name before entering into any commitments of relationship, business, or marriage. All mischievous attributes of dishonesty, unfaithfulness, disrespect, and deviance humbly wait for you to say, "I do." Jezebel submitted to no one. Not even the lover of her life, the acting king, could subdue her political behavior that enabled her to become the queen, though in essence she was the acting king!

4 *Unmasking the Jezebel Spirit.*

The root meaning of her family name had a generational curse for murder that stemmed from the father, Ethbaal, which meant "like unto Baal." The reign of her father as king came as a result of injustice by plotting murder.

Jezebel has a speech agenda that is most deceiving, cunning, and self-gratifying. The spirit of Jezebel respects no one's opinion only if she is the one in charge.

Exposing the Jezebel Spirit

- The Jezebel spirit is domineering in silencing the prophetic ministry in the churches today simply because her secret deeds are surfacing through this ministry of utterance.

- The Jezebel spirit paralyzed the vision of the church by attacking the heart of the worship and prayer.

- The Jezebel spirit doesn't seeks divine revelation from God; rather it seeks information through the act of apostasy and hypocrisy.

- The Jezebel spirit establishes strongholds in the minds of people, making them feel belittled and inferior.

- The Jezebel spirit is influenced and supported by contentious, manipulative, domineering, and rebellious spirits, which is contrary to the leading of the Holy Spirit.

- The Jezebel spirit likes to fuel fire by exalting self and demoting others.

- The Jezebel spirit seeks to torment instead of establishing peace that passeth all understanding.

- The Jezebel spirit is programmed to manifest when certain key factors or problems arise.

- The Jezebel spirit is jealous of the anointing when in operation.

- The Jezebel spirit is quick to make assumptions through the eyes of supposition and not illumination.

- The Jezebel spirit is associated with lying lips of abomination and tale bearing and transmits irrational behavior.

- The Jezebel spirit is very crafty, influential, and subtle in the lives of the church, privately inflicting more wounds to the wounded.

- Jezebel spirit likes to shut down the network program design in the church to expose besetting sins.

- The Jezebel spirit likes to disconnect the source of supply to the believer.

- The Jezebel spirit is very controlling.

- The Jezebel spirit is very discrediting, especially on the male part of leadership.

- Jezebel spirit never seems to see her fault when she is wrong and her spirit of dominance never seeks to apologize. If she does that, it will take away the power of her belief, rights, and position.

- Jezebel is a crying demon; when things were not going her way, she seduced her husband into killing Nabal.

- Jezebel is a crying demon with deception. She is crying, but her heart is saying something else.

- Jezebel doesn't like to say, "I am sorry." She will have nightmares in her sleep.

- Jezebel spirit always has an answer for everything because she is a strategist.

- Jezebel is very influential, cunning, and hateful. She lies. Don't get carried away.

- Jezebel walks with a blanket of seduction instead of a robe of righteousness.

- Jezebel likes to be on top of everything in the church. She will assign titles and even mandates to herself, saying it is the Lord. Remember she calls herself *prophetess* in Revelation 3.

- Jezebel is very conflicting in decision. The suffix of her name, *bel*, speaks of contention, greed, and controlling

Twenty-Eight

Jezebel: Spiritual Combat

This fighting and jealousy spirit comes under one big heading: Jezebel. The weapon of God can never be carnally joined with carnality or spiritually interrelated with such nature of apostasy.

For we wrestle not against flesh and blood but against principalities, against powers, against rulers of the darkness of this world, against spiritual wickedness in high places (Eph. 6:11–12).

For the weapons of our warfare are not carnal but mighty in God for pulling down strongholds, casting down arguments and every high thing that exalts itself against the knowledge of God, bringing every thought into captivity to the obedience of Christ (2 Corinthians 10:3–6).

Spiritual combat is in the church. Why are we fighting the wrong individuals for the wrong purpose? It is because of the different strongholds that have gained access through the entrance of our thoughts, emotions, decision making, and our physical bodies. It is also because of the immaturity of our mind. Most of us are accustomed to fighting *fleshy battles* against each other. What we must try to recall is this: the battle is very personal and close; the enemy is a spiritual one and the weapons are spiritual.

The weapon of God can never be carnally joined with carnality or spiritually interrelated with such nature of apostasy.

The battle is the Lord's, therefore, we should let go and let God fight our battles. Jehoshaphat

and his men were assured by the word of the Lord concerning this predicament.

> And he said, listen carefully, all Judah and you inhabitant, and King Jehoshaphat. This is what the Lord says: Do not be afraid or discouraged because of this vast (mighty) multitude, for the battle is not yours, but God's. Tomorrow, go down against them. You will see them coming up the ascent of Ziz, and you will find them at the end of the valley facing the wilderness of Jeruel" (2 Chronicles 20:15–17, NKJV).

You need not to fight this battle. Position yourself, stand still, and see the salvation of the Lord. He is with you Judah and Jerusalem. Do not be afraid or discouraged. Tomorrow go out to face them, for the Lord is with you.

When our life is completely sobered and directed by the power of the Holy Spirit, then we will be able to know the wiles of the devil in spiritual warfare. Jehoshaphat and the people stood still and obeyed the voice of God. When you know that the Lord is your redeemer and He is in total control of the situation, this is the time for your faith to be lifted and your confidence renewed.

> When our life is completely sobered and directed by the Holy Ghost, then we will be better able to know the wiles of the devil in spiritual warfare.

Here in the text, God reassured the people to stand still and see the salvation of the Lord. The operative words are *stand still*. Standing still denotes a military formation that is constitutional once you are a soldier. However, the etymology of the phrase *stand still* strengthens the cambium of the plant; once faith is exercised to be still and know that He is God Almighty. The root meaning here is that *I am in control, peace be still. Just be calmed. I have everything taken care of. Just leave it to me, I will handle the problem.* Standing firm in the storm is not the problem, but it is to stand secure knowing that you are comprehensively covered by your insurer— God. When we can have this confidence, then some of the battles fought would have been won a long time ago only if we did as commanded. In our struggles with principalities from high places, just follow the illustration here in the text and you will win your greatest battles.

God had to comfort these people primarily for them not to be confounded by the mighty army of Assyria. We need to realize that the devil can only come this far, but not close in our life, business, family, and church. God was telling them to be upright, unmovable, and uncompromised. When God is in our vessel, my friend, we can smile at the storm.

I believe that you and other associates have come under heavy attacks similar to that of Jehoshaphat that get you depressed, discouraged, and disorganized, but the end of the journey is not concealed. The flight has not left the runway. Get onboard and overcome this fear in Jesus' name. God is saying to me to tell you right now that your confidence will grow into a gigantic plant; yes, you will even increase more in your faith because faith is the substance (anointing) to produce the things not seen. God will direct you where to fight this battle, what to do, and what to use. The spirit of the Lord wants you to use the power of worship to confuse his plots (the devil). You see, my friend, the devil cannot plan for your life. He can only plot against you falsely for the sake of the blood of Jesus. Oh, yes! All we need is to be still in this battle and the Lord will most definitely do the rest. Will your anchor hold and grip the solid rock while you face your greatest enemy? Don't run away—for God has not given you the spirit of fear but of power, love, and sound mind.

David confidently declared in Psalm 46:10–11, "Be still and know that I am God: I will be exalted among the heathen; I will be exalted in the earth. The Lord of hosts is with us; the God of Jacob is our refuge.

Paul was very instrumental concerning the nature of spiritual warfare as he wrote this classic manuscript in Corinthians: "For the weapons of our warfare are not carnal, but mighty in God through the pulling down of strongholds and casting down every imagination that seek to exalt its self against the knowledge of God" (1 Corinthians 4:3–5). These words of warning come directly from the throne room in regard to the saints against the spirits of Satan. Pulling down and exalting self correlated to that of Jezebel. Further, in this chapter you will definitely discover Jezebel's ability in "pulling stronghold spirit of imagination." We are to pull and push others instead of pulling and sinking them deeper. It takes someone lower than you to pull you down irrespective of your status. Truth is simple truth.

The world needs us. The people that evolve around this globe are looking to us for help, guidance, and a life like Christ's. Satan has a method and an

established plan to conquer each one of us, along with our family, church, community, and nation. Unless the battle of self is crucified at the cross and the inroad of ignorance and darkness are blotted out successfully, this monster will continue to assault the body of Christ. The devil has an interest in every one of us. You and I are microwatched and sometimes micromanaged. We head his warrant list, and summons have been served many times for our arrest. However, we are God's frontline troops fighting the good fight of faith and quenching his fiery darts with the shield of faith. Our confidence is growing stronger and stronger as we practice self-deliverance by renouncing them and speaking the word of faith with authority.

Fighting the good fight of faith is not with our brothers and sisters; it is with the devil. Making our calling and election surely is one of the prescribed requirements on that glorious day.

Spiritual combat is a fighting force having composite factors of hatred, jealousy, and competition. These factors are very common in the history of the church. Christians can be easily puffed up with the spirit of pride, resentment, thinking of themselves better than others, and thinking of themselves more highly than they ought to think. I have seen this force in the form of spiritual dominance in the church—the kicking, punching, boxing forces that leave the believers defeated and of no significance or importance.

> ଛୠୠ
>
> Fighting the good fight of faith is not with our brothers and sisters, but with the devil.
>
> ଛୠୠ

As I see this manifestation, I really wonder what would motivate these people to behave in such a way. Was it God? I secretly questioned myself. But one thing the voice of God comforts me with was *the anointing is never recognized but always revealed.* He said to me, "I am not a God of confusion and contention, but a God of consolation, comfort, and confirmation." My friend, for six months this ministry was severely under a heavy curfew of principalities. Sunday after Sunday, the same force of darkness would saturate the service, making members fight each other in the flesh. This demon was so pernicious to the point where the church was operating on a low cash flow. Everything ceased drastically as a result of this spirit of dominance.

The following Sunday, to our surprise, Mrs. Jones and two other confederates joined hearts wholeheartedly to establish their own super

kingdom in the church. The tower of Babel was building with the aim to find God, but their plans failed. The assistant pastor was their helpmate because his voice in the church was silenced and his position was compromised by fear, doing the opposite to the word of God. He was like Saul at one point doing exactly what they declared was good to their taste. The spirit of democracy was the order of the day. Where was God? A kingdom that is divided against itself cannot stand against the knowledgeable and magnificent power of God. Every meeting called by the assistant pastor was boycotted by these two champions, until one day the Lord in His infinite power anointed this man of God to counteract their lascivious deeds in shame and confession. No one could leave church that night until God did what He had to do.

There was always a traitor in every game of history. It may not be a Judas, *Achan,* or Delilah, but somewhere in the midst of greatness lies a spy whose report is contrary and subtle. As we stand in line waiting for the command from God's servant, this person could not face up to the instruction of the Lord so she realized what was required and cunningly walked away. She discerned what was coming and discreetly walked away from the presence of the members, but not from God. Her next adversary was trapped by the glory of God as she cried for mercy and pleaded to God to change her evil thoughts and evil doings. The act of deception was, however, evident with conclusive personalities to that of Jezebel. Her countenance was characterized by a counter expression of association of strongholds; eyes were closed, faces wrinkled as the power of God exposed all her secret missions. She cried and cried, but I was not moved by her emotional craftiness of deception. She was a strategist analyzing us with her detective skills accommodated with the simplicity of attraction in conjunction to Jezebel. We left revived but still on double watch to see what would transpire as the days went by. Surprisingly the ants nest of principalities was summoned to battle. For the remaining week, we had some encounters with spiritual witchcraft breeding from all angles in the church. But to God be the glory! We were on twenty-one days of fasting knowing that this would happen to face these demons.

Every high thought was subjected each night with a new level of the anointing—the devil lost big time each night as the Lord would anoint his servant with different Scriptures, vision, and principles to defeat the strong man in our midst.

We must first bind the strong man to take hold of our possessions. Victory is in your faith and not your strength.

Strictly speaking, the Bible clearly emphasized the imperativeness of this in Matthew 12:28–29.

> And if I cast out devils by the Spirit of God, then the kingdom of God is come unto you. Or else how can one enter a strong man's house, and spoil his goods except he first bind the strong man? And then he will spoil his house.

When no accountability is made for the sole purpose of honesty and the proper funding of expenditures, the background of such cause must not be taken lightly because a pernicious spirit is somewhere working undercover.

Prayer Mantle Agreement

I charge all prayer prophets and warriors to put on their spiritual glasses, take up your seasoned position, look discerningly at what is happening in front of you, and see if some of the manifestations are not associated with the Jezebel spirit that is dancing in the churches today. You may be under this attack right now as you read this powerful revelation on Jezebel, but I assure you, my friend, that you will not perish under this leadership of influence. I believe God that the yokes of depression shall be utterly broken from your life, family, calling, and business in the all–knowing, powerful name of Jesus. You will no longer face dispute, insult of integrity, or reproaches.

The wind of God will blow once and for all in you and this mighty wind will be like Acts 2 to grant the desires of your heart. Receive this release of divine favor *now!* No more attacks! It is over!

Twenty-Nine

The Spirit of Greed: Jezebel

One of the characteristic attributes of the flesh is the unsatisfying pleasure for more gain legally or illegally. The mother of jealousy is Jezebel. She could be neither satisfied nor pleased in conjunction to her contentious greed of domineering others. This type of dominance was seen in a battle with her husband for Naboth's garden (1 Kings 21).

The spirit of Jezebel will get you flustered making you want to run away from the mandates handed down to you. She is out to kill and take possession of your belongings; therefore, you have to be strong, fearless, and courageous to stand against her wiles of deceptions. She coveted Naboth for his provision by doing a survey of the produce and product qualities of the garden before carrying out her plan. Jezebel will not attack you immediately; she likes to seek information on you *before* deceiving you. Let me tell you something of importance: you are possessed with God's possession already. There is a *reservoir* of power residing in you the very moment you were born, so your Jezebel may take your possession, but the seed is planted in you to produce more and better fruit. In other words, the possession of harvest is in you. A harvest is not a result of reaping until seeds are sown in the soil. What I am saying is this: you are that *seed harvest* for this generation. Your garden is taken, not the produce; the garden will die under her management and maintenance, but the seeds of the harvest will last as long as they are stored.

A Jezebel's Spirit seeks information, not revelation.

You Are Possessed with the Anointing to Take Possession

> Now unto him that is able to do exceedingly, abundantly above all that we could ask or think, according to the power that worketh in us (Ephesians 3:20).

Don't let the spirit of Jezebel try to speak or convince you in giving her what does not belong to her. The battle is the Lord's. He will fight for you, my friend. Why would you covet someone else's gift? From the Old Testament to New Testament, a gift is given to glorify God in the good and bad times. Taking away the gift will not glorify God; it will dishonor the purpose for which it is intended to do.

In the account of Jezebel against Naboth, the spirit of charisma was used mainly as a tool of persuasion. Many of us today are solely deceived by charisma for the anointing. Mistakenly interrupting charisma for the anointing is of concern for me in the church because many lives will be captured by this mode of craftiness. However, we must be keen nonetheless with to the root word used in reference to the anointing. The word *anointing* and *unction* are used simultaneously and interchangeably in 1 John 2:20, 27. Both words are translated from the same Greek noun *chrisma*. It is used figuratively as the endowment or bestowal of the Holy Spirit upon the saints. It is also the relational noun of the Greek verb *chrio,* which is translated as "anointed." *Chrio* means "to anoint or to consecrate for sacred office." Quoting from *The Maxwell Leadership Bible, charisma* is defined as "a magnetic personal persuasion that draws others to the leaders, making them feel better about their selves."

- The spirit of Jezebel manipulates people she cannot move (1 Kings 19:1–22).

- The spirit of Jezebel uses position to manipulate others.

The name Jezebel is derived from Phoenician origin and means "un-husband." It has also a Hebrew meaning, which is "Baal is husband" and "inability to cohabitate." She controls. She leads. She rules. She wears the pants.

- The spirit of Jezebel targets those who are vulnerable because they are easily influenced and controlled.

Quoting from John Paul Jackson *(Unmasking the Jezebel Spirit)*, "The longer someone operates in a controlling and manipulative way without repenting from doing so, the stronger this spirit grows."

Thirty

Jezebel: Ice Breaker

For the past four months, the glory of the Lord was transforming the members from glory to glory. The flow of prophetic utterance was evident, supernatural power from above was pure, and fellowship of church growth was encouraged as the Holy Spirit poured daily in our lives. We were all eager to see what the Lord would do next through his servant. While the continued flow of anointing overflowed in the morning service worship, we encountered a booby trap: Mrs. Jones was on the scene—the apex of worship was never the same again as a result of an *ice breaker* cyclone experience. Where it developed was not strange. It was from the same source of deception. The service turned into *Ichabod* and the glory of the Lord departed that day from the church. From that day until today, that particular church has never seen the glory of the Lord in that form again.

The membership of that particular church started to decrease as it was exposed more and more to Mrs. Jones's style of leadership (manipulative), teaching, offering, and preaching. The glory departed little by little like a moving cloud from light to darkness. What had transpired? The heart of manipulation surfaced so much that the church that was once Holy Ghost-filled started deteriorating. A strategic plan was later implemented with new vision leaving the council of the church in further disarray.

A worldly plan of action started to take place. Demotions of offices were done to gain prominence with the majority. Votes were secretly discussed and decided as to the administration of the church. Primaries were not as important as super delegates. The church had adapted democracy for theocracy. The voice of God was no longer necessary to follow. Everyone turned from the voice of God to the voice of deception. A great apostasy

was in the church. A cloud of darkness was seated over the pulpit. There was no rain or sun because the church was a cesspool of apostasy.

The Great Apostasy spoken by young Timothy (1 Tim. 4:1–4).

There is a road that seems right to every man, but the end thereof is destruction without God's providence.

Now the spirit expressly says that in latter times, some will depart from the faith, giving heed to deceiving spirits and doctrines of demons.

Speaking lies in hypocrisy: having their own conscience seared with a hot iron, forbidding to marry, and commanding to abstain from foods that God created to be received with thanksgiving by those who believe and know the truth.

For every creature of God is good, and nothing is to be refused if it is received with thanksgiving; for it is sanctified by the word of God and prayer.

As the Lord God of Israel lives there shall not be dew nor rain for this year, according to my word until there was true repentance (1 Kings 17:1, NKJV).

The entire service was under a curse of unholy alliance. Seeing the truth and not being able to speak made us unholy. Our righteousness then is like filthy rags. We were like dogs returning to our own vomit because of disobedience to the Lord (Proverbs 26:11). Everyone's concern and anxiety resolved around what would happen next. We sang but our hearts were somewhere else. The changes that were made brought in a diabolic spirit of dominance with an unraveled behavior. The church was so puzzled by this manifestation.

Man's glory must die for the glory of the Lord to be birthed.

For months on months, a spirit of darkness rested over the church. King Persia had succeeded in establishing his domain in the church. Spiritual combat of *word dropping* was happening each Sunday, manifesting under a twofold spirit with heavy operation of false pretense. The glory of self had taken the place of God. (See 1 Samuel 3 and 4 and Psalm 115:1.) God's

church was seen as a club; the members came to church any time of the day, dressed how they felt, and praised and worshipped when they felt. (See Hebrews 10:25 NKJV.) They thought they were doing God a favor by treating His house like a den of thieves. (See Matthew 21:13–17).

There was no Mrs. Jones. The body parts of the church were spiritually dislocated from the brain. This time it was the hand and foot telling the brain what to do. She placed these cohorts to hold things intact until she was back. These new appointments to them were seen as protocol and vision of newness of structure so that the church could be properly organized, but this caused more falling away. The increase in deception succeeded in making the matter more severe. Church was never the same. No one could see his or her mistakes. Fingers were pointing to everyone, and prophecies were meaningless to the people. No one took heed to the warning of God's servant, and everyone did what was right in his or her eyes. (See Judges 21:25.)

Month after month, we did not experience or see any cloud forming in the sky. We looked and looked and waited for the hand of God to write on the wall, but there were no signs and wonders to be found as the church experience more famine. Even though no one was seen to be genuine, we, however, looked beyond the norm and humbly waited upon the Lord. All prophecies given to me during the events were fulfilled in our eyes. There was no rain until one day God finally decided to speak to his servant Elijah to sound the alarm in Zion. The Lord instructed a solemn fast of twenty-one days, and told the prophet to tell the people to clean up the mess.

We all did what the Lord had commanded us to do, but strangely enough there were still some Tobiahs and Sambalots who were sheep in wolves' clothes pretending as if they were in agreement. One day the *bitter gal* in some of them burst and exposed their thoughts of delusion. The atmosphere was charged every night as we battled with the forces of darkness, demons from all angles presenting themselves to investigate the order of the night, but they were rebuked publicly as the Holy Ghost gave us the utterance of prophetic authority to do so.

Jezebel spirit has no respect for male leadership. Her aim is to discredit the work of God through you. The all-night prayer meetings were evidently supported by the obedient members and not by her associates. Not one of them was in agreement with the direction from God's servant.

The Spirit of False Humility: Jezebel

She was surrounded by a number of ladies who possessed the same behavior in character. They were parallel. She would put everything on hold to sanctify her greed for prominence and recognition, using the Lord's name as a scapegoat in vain so that the people would be deceived by her treachery. It was very hard for her to come and sit humbly in a service that was under the anointing and the direction of the Holy Ghost. Holding her peace and watching the service was like committing suicide. She could hardly contain her subjection under the influence of the Holy Ghost. Her body tingled to the point where she started mincing in the congregation with wanton eyes of sedition, trying to take the service from the moderator.

Our speech can be a big result of our association.

During my studies and personal eye witness to the behavior of this spirit, I have discovered a few things that are worth mentioning in this book. It is fascinating to know that she is a woman jealous of academic achievements. Pride, though, is one of her greatest downfalls, while mediocrity is greatly recognized whenever she is around. I find that very bizarre at times. Her false humility is very appealing to the core audience that she seeks but serves to further entrap and convince them with false prophetic promises. This behavior is very deceiving, making one feel good that every promise will be fulfilled. This is a cunning and deceptive spirit that is misleading and is deeply rooted in a lot of our leaders today. She was no ordinary woman, as I said before. She is very prolific in nature and passionate in action to see things done quickly, even if it has to go the other way around, as long as it is done—holy or unholy—to please her. She is very outspoken and never afraid to attack the problem or to get at you, which sometimes lacks wisdom on her part.

She loves to seek out the most prominent businesspeople in church. In her own small way, she will discreetly use manipulation to get you in her office to sow seeds of discord and animosity so that you will feel sorry for her and join in the deceptive motives. In doing this, her aim is to collect as much money to gain fame and popularity. Her greetings are very polite and seasoned to the bone, likened to the lilies of the valley and the bright and morning star. It was one of a kind. Don't be misled by what you see on the outside. It is what's on the inside of the person that is creative and

destructive. When David was to be anointed as king over Israel, Samuel, the man of God, was looking on the stature and masculinity of Jess' sons, but in the infinite wisdom and power of God, it was supernaturally different. God was the one to remind Samuel what the resume curriculum (sure)should be like: "Man looks on the outside, but God looks on the inside." As a result of this requirement, David was chosen and anointed king over God's people, and, amazingly, he lived up to the expectation and brought wondrous victory and glory to the house of Israel.

Familiarity Breeds Contempt

Seeing her for the first time would make one say, "Yes, she is really a woman of God." *(Oh yes!)* She is hearing from God and leading us to the path of righteousness because she is meek and her humility is genuine. We, at that point of zealousness and being anxious, look on the outer appearance and not the inner man (1 Samuel 16). Having zeal is good, but is to have zeal with discernment of spirit that will bring growth and change to the body of Christ. Many people are trapped in the web of Jezebel because they lack the spirit of discernment. Many lives and marriages have been severely destroyed with a category 5 *Jezebel storm* as a result of the lack of discernment.

As a servant of God, I don't follow signs and wonders. The Bible did not sanction this jurisdiction on that premise, but that signs and wonders will accompany the believers in Christ. I believe Christians must be signs and wonders, and reason for that is we are light and salt; therefore, the Christ in us must draw others to Him (God).

No service directed by the Holy Spirit would end without her having the final say. As she continued to display this domineering agenda, the membership of the church started to decrease rapidly. The church was no longer transforming from glory to glory; instead, it was de-transforming from righteousness to unrighteousness, from moral to moral decay of unholy alliance. The spirit of Dagon takes pre-control in the leaders of her choice. (See 1 Samuel 5.) Sickness and death were finally introduced, by God the Father, as a sign to repent for the displeasure of sin and desecration of gifts at the altar and through the introduction of democracy. The church was summoned by the next high priest to pray and set thy house in order for the death angle was going to visit the ministry. The death angle did visit and take many lives including one of the senior officer's sons. The history

of Exodus was repeated in this ministry as Moses warned Pharaoh to let God's people go. There is a saying from past tradition: *who can't hear must feel.* We were all experiencing severe punishment for our disobedience.

Prayers were offered, but there were no great changes. The spirit of conflict, disunity, contention, and confusion with pride filtered through every avenue in the church where it was so evident by the nightly attendance. The membership of sixty was now six members for at least three months. Where were her associates? Nowhere to be found. Her associates were only interested in Sundays to come and gain recognition for their outstanding role of hypocrisy.

This Jezebel spirit tore away the fiber of spiritual integrity so much so that a new level of lifestyle began to manifest in the sanctuary, disgracing the standard of God's holiness. From here, and further, the church was left in a state of decay and stench that was beyond any spiritual comprehension.

As spiritual watchmen in Zion, let us gird up our loins and minds in total vigilance to this python spirit that is demoralizing the ordinances and doctrines of God, turning people from the truth unto fables, erroneous teachings, and infidelity of submission. The influence of this spirit does exist today through the seeds transplanted by Ahab and Jezebel. It has never been eradicated from the church. Instead, it has gained root in a resolute dimension that only brings unholy alliance to the body of Christ. Paralyzing this python spirit is not fought humanly, but spiritually. (See 1 Cor. 4:9–10.)

Doing away with the entire household is absolutely the only option to control or put a stop to her dominance. The Bible says King Jehu ordered her (Jezebel) thrown from the wall. The old proverb says, "If you play with fire, it will burn you."

Thirty-One

Ahab's Spirit

(Where there's a Jezebel, there's an Ahab)

A Compromising Spirit (From 869–850 BC)—1 Kings 16:31

Seeing the truth and turning a blind eye doesn't make you better than the deceiver. King Ahab, Israel's king, was caught in this web of deception under the leadership of the commanding chief, the famous Jezebel. Instead of Ahab ruling the kingdom assigned to him, it was the ruling master Jezebel who manipulated Ahab to compromise his position through the act of intimidation. Historically speaking, wherever there is a Jezebel, there is most definitely an Ahab.

> ℰℭ
>
> Where there's a Jezebel there's must be an Ahab. Ahab is controlled by Jezebel.
>
> ℰℭ

Any office or position that stimulates you to compromise so as to gain prominence and favor is personified by Lucifer himself. King Ahab held an office that denoted authority on his part. He held the highest rank in Israel as king while his wife was the queen of his domain. The spirit of Ahab speaks of one who is very timid to the truth, flustering in speech delivery, twisted language manifestation, defenseless, passive, and fearful. Someone with an Ahab spirit would rather compromise, even if it leads to making an unholy alliance.

A pastor friend of mine was asked to pray in a member's place of business. The time and arrangement were all set and in place; the pastor was notified by the prayer mothers and was asked to visit. While getting ready to attend, he got a call that the time had changed and if he could make it a little sooner. For sure, the pastor tried his best, so he went and

picked up the prayer team. However, he was confronted with attitudes from one of the senior mothers of the church who should have known better. To maintain the peace of God that surpasses all understanding in their midst, the pastor willingly accepted the wrong wholeheartedly, which was an act of compromise. He acted like Ahab. I was shocked when the prayer mother disrespected the man of God in my presence and at the same time presumptuously dictated to him. He gave in to the pressure of that domineering spirit of stronghold and compromised his office to seek peace. I cautioned the pastor to observe such spirits and to boldly rebuke its behavior. I then made it clear that it would resurface and generate further harm and could cause obstacles in the ministry.

I believe this songwriter was inspired instrumentally by God to write in such an illuminating passion. He was touched with double power from above.

Declaring Triumphantly

My hope is built on nothing less
Than Jesus' blood and righteousness;
I dare not trust the sweetest frame,
But wholly lean on Jesus' Name.
(Chorus)
On Christ, the solid Rock, I stand;
All other ground is singing sand,
All other ground is singing sand.

When darkness seems to veil his face,
I rest on his unchanging grace;
In every high and stormy gale,
My anchor holds within the veil.

His, oath, His covenant and blood,
Support me in the 'whelming flood;
When all around my soul gives way,
He then is all my hope and stay.

I dare not trust the sweet frame,
but wholly lean on Jesus' name.
Your very own will fail you.

I know within my heart that many pastors have embraced this behavior in the church and at times are afraid or too timid to speak out on numerous occasions. Some may even convince you to remain and continue to do the good work of the Lord, but deeply you are hurting from speaking the truth. Maybe you are seen as someone who is spiritually immature to what is going on, but as I write this book I know that you are able and capable to do the task handed down to you from above. Though you are so surrounded by a great cloud of Jezebels, the heart of manipulation, the strongman will soon be bound using the authority and power given to you. I encourage you, pastors, to not strike a compromise ballot. It will weaken your authority giving way for the spirit of seduction and devils of doctrines to saturate the church. It will affect the growth, spiritual prosperity, operation of gifts, and the overflowing of the anointing in the church. Capitalizing on these demonic utterances in the pulpit arena is through prayer and fasting, especially for the pastors who are caught in this deadly trap. What more could the pastor do than to hold his peace and let the Lord fight the battle? He could have rebuked the prayer mother because he had such authority from God to do so, but instead he allowed the fruit of the Spirit to gain control of his emotions and thoughts and wisely dismantled such a spirit.

On several occasions, I have watched pastors compromise mainly because of fear that an individual will split their church, tithing will decrease, and popularity will be hampered. Also, I have witnessed pastors and officers remaining indecisive and confrontational about the truth—the spirit Jezebel and Ahab are at work! Having fellowship with these persons should not be entertained. When they come in agreement, it is to propagate you rather than edify you. Their goal in life is to use, drain, and destroy you, rendering you helpless to your family and the community. Jezebel through Ahab is to mar your reputation in life so that you will not be locally or internationally recognized and respected. But be encouraged for the joy of the Lord will be your strength in this battle.

Living in self-denial will not rectify the problem. Coming out of the box of imago to be transformed from glory to glory will only get the job done.

A Contrary Spirit Unequally Yoke: Ahab

From the beginning of creation, we see God's covering for a man and a woman. In contrast to their covering, the spirit of man was covered by God, and the woman was created to be spiritually covered by the man. Man

was pulled out of the earth physically while woman was pulled out of the side of man physically. This was done to teach the completeness of God in marriages and show the order of command directed by God. The idea of this was to show the difference in *covering* and *order of command. Covering* speaks of completeness. *Order of command* denotes functional and operational duties. The head of the church is God the Father and He did not operate out of His own authority but in accordance to the will of His father. (See John 5:19.)

Every living creature is under the authority of either Jesus Christ or under the influence of the devil. A child of God is under the authority of Christ. A woman is under the governance of the man. The head of a woman is man—her father—until she is married. Children are under the authority of their parents. Jezebel was to be under the authority of Ahab, but as a result of her controlling dominance and political strategies she maneuvered Ahab's authority into a power position. This act was contrary spiritually in God's chain of command and unequally yoked.

In Ephesians 6, Paul admonishes the order of command:

Wives, submit yourselves unto your own husbands, as unto the Lord.

For the husband is the head of the wife, even as Christ is the head of the Church: and He is the savior of the body.

Therefore as the Church is subjected unto Christ, so let the wives be to their own husbands in everything (Ephesians 5:22–24).

The one who is responsible has authority; the one who has been given the responsibility has the authority.

Playing with Fire: Contrary—Ahab

Ahab enables Jezebel to function with authority and responsibility. He abdicated his place of authority. By his actions, he was acting contrary to the word of God. However, this denotes that he was passive in authority, tolerating the spirit of idol worship and insanity, agreeing with sexual perverse acts, playing with fire, and conspiring with evil. Persons with this type of spirit demonstrate fear, lukewarmness, passiveness, and unholy alliances, are weak confrontationally and seek high office positions,

act defensively when their authority is challenged, and embrace godliness, but they deny the power thereof. He is not a good leader in his home and refuses to set good examples for the children. Little by little, responsibilities are transferred to the wife who is the primary caregiver for the children and has other duties in the home. From my knowledge, it was clear from day one that she had a plan—an agenda.

Disorders in the homes can ruin a child's future academically, socially, mentally, and psychologically. This was what happened to Ahab's children. They patterned the same principles demonstrated by their parents in like manner. The Bible warns against this admonition in the book of Proverbs: "Parents train the child in the way he or she should grow and when he or she is old he will never depart from the teachings. There is a saying that, "children lived what they learn." In the account of this couple, the same was transpired with the children. Jezebel's daughter, Athaliah, became queen of Judah and did just like her mother. She looked for a husband who was passive and weak so that she could overpower and practice witchcraft. The sons likewise were contrary in their habitual sinning and doings like the father.

Today many lives have been destroyed because of this same monster, Ahab. Many homes and relationships are broken up as a result of this spirit. Many have become homosexuals, domineering, and controlling because of the surrounding of their parents who at that point were controlled by demonic influences of Jezebel and Ahab.

> The spirit of Ahab is an unequal spirit in functions and responsibilities.

The spirit of Ahab is an unequal spirit in functions and responsibilities. What we must understand is this: acting contrary to the truth will only sink the ministry deeper and deeper. If such leaders or pastors are not monitored by a stronger leader, it will be difficult to discern the wiles, deception, manipulation, and intimidation of this spirit. The church will continue to increase in spiritual decline and depression, preventing the flow of prophetic utterances and vision of directions. A pastor or leader who acts contrary only opens doors for more darkness, confusion, contention, and strife, which will spiritually constrain the church.

Pastors like Ahab who know the golden rules of Scriptures and refuse to conform will bring disgrace and punishment upon God's people. As

long as the spirit of contrariness is among the church, God's people will circle like the children of Israel. So preventing this from taking root, the leaders must be willing to come from among *them* and be separated, thus presenting his body as a living emblem holy and acceptable unto the Lord—which will reproduce a fresh wind of God's gifts in the body. One cannot be ignorant to this device because the spirit of Jezebel is specifically targeting pastors who are foreign to her moments and coming under the attacks of this spirit will affect your ministry. In other words, you cannot conspire with every speaker to arrange speaking engagements. If so, you are assisting the food-chain reaction to increase and create famine in the church. God's manifested glory will not be present, so the only solution is to call a fasting of repentance at Nacon's threshing floor. (See 1 Chronicles 13:9.)

The word of God says,

> A double minded man is unstable in his thoughts and ways (James 1:8).

Admonition, unity and sound doctrine by Paul's writing :

> Now I beseech you, brethren, mark them which cause divisions and offences contrary to the doctrine which ye have learned; and avoid them (Romans 16:17).

> This fellow (Paul) persuaded men to worship God contrary to the Law (Acts 18:13).

Avoiding the Truth: Ahab

I honestly can't take the hypocrisy in the churches today. It is an insult to the Holy Spirit in operation and secondly to your faith confession. The hide-and-seek games, meetings, agendas, and church parliament do not work in Christendom. They are weaponry that will bring judgment on ourselves if we are not keen to the leading of Lord. Our bodies are the instrumental temple of the Holy Spirit and therefore we are admonished to present it holy and blameless.

People cannot change and negative circumstances cannot change until there is an acceptance of personal responsibility for sin.

David, the Bible says, repented of his wrong doings by wholly acknowledging the cause of his sin in Psalm 51. As leader or shepherd, we can uphold wrong ministrations among us and the sheep. We have to set the prerequisite standard against the spirit of indecision, conspiracy with darkness, delusion, compromising, and dishonesty, or else the church will continue to face spiritual challenges, famine, judgment, no revival, and no growth. God's manifested presence will be removed from the sanctuary and only dwell with those of clean hands and pure heart. (See Ps. 24.)

A pastor who compromises will attract people who compromise.

What does it takes to say you are operating contrary to the word of God? What does it takes to reveal the truth? What does it take to say, Lord, I have repented of my ways and wrongdoing? What does it takes to acknowledge our faults among each other? It takes *humility* and *love*.

Tolerating Hypocrisy

We are justified by faith! When a person becomes rebellious, it's when he or she simply ignores in general right from wrong. He is saying, "Yes, I comply and am in agreement with what is going on." It is shown that most pastors have a level of tolerance toward their *buddies* (minister friends) and are quick to overlook their faults and loyally promote and condone them in ministry. But that is not doing good to you or your friend because at the end of the day that same person is going to exhibit similar character traits in the pulpit or in public. If it was strictly rebuked, it would not have surfaced. A good friend said to me that, "I should to maintain a line between friendship and pastoral care and counseling." A line has to be drawn clearly.

An open rebuke is better than secret love (Proverbs 27:5). A pastor who fails to correct any spirit of unruliness or rebellion is compromising his position and will lose noble respect from the members and community. He will bring disaster on the body of Christ. The church will decrease in glory; growth and confusion will set in like a threatening storm thus aborting the purpose of God for you and me. The pastor's anointing will no longer be effective in preaching and teaching the word of God. The church will come under a heavy attack of missiles of darkness, poverty, famine, manipulation, and domination. The spiritual lamps of the believers will

grow dim and dimmer as the body begins to lose sight of the midnight cry. The church would become like the foolish virgins, as in St Matthew 25: empty, useless, confused, and miserable.

Yes, my friend, you may be experiencing these same problems in your church, life, and family, but I know that the God we serve can do it again for you. I charge you not to compromise or to tolerate evil because the wrath of God will start with you first. You may be going through a rough time, but I speak a divine breakthrough over you right now in the name of Jesus Christ. God is saying to tell you that He is going to pull you out of that situation and make the path possible for you again. You will be able to minister effectively again.

Would you rather sit in an office of compromise and see the ship sink with you onboard? The mind is a place of evaluation. Therefore, no, you would not do that. You will try to save yourself from drowning. There comes a time when every spirit of conspiracy will be exposed, knowing and unknowing. Judgment will come on such leaders who refuse to recognize their error and repent. According to the song writer, "Search me O God and know my thoughts I pray, and try me and see if there are any wicked ways in me" Reference scripture Psalms. 139 .

Thirty-Two

Get Caught in the Web

Confronting your greatest fear is the battle to victory. Pastor Rod Parley once said, "Fear is false evidence that appear to be real." During my tenure at school, church, and home, I was very ignorant facing the truth. I would easily get on the offensive side. I did not know how to deal with such situations mainly because I was fearful. Confrontation was my biggest fear then. As a result of this fear, my spiritual father had to find a different method of approach whenever he wanted to talk to me. This spirit of nervousness and intimidation would cloud my mind from reaching out to others and even my dad. I wrestled with this trauma for years and even in ministry today, but I read and continue to seek the face of God gradually so I overcome.

I discovered that it was a demonic spirit that I was battling and was unaware of it. Most of the time when I knew the truth and compromised, I felt completely different and isolated. The presence of God was not with me, and I became angry with myself and felt as if someone speared my heart with an arrow. Little did I know that I was actually grieving the Holy Spirit. I was afraid to confront my friends and fellow brothers and sisters with the truth.

My prayers were no longer effective, and each time on my knees in prayer I would remember these things and ask God's forgiveness. I still feel the guilt. I was living in a compromised shell, pleasing the people and not God. I paid the penalties for disobeying the voice of God and had to start all over again. How did I overcome? The word of God helped me speak the truth and the truth shall set you free—be not entangled in the yoke of bondage. These words along with prayer and fasting gave me the boldness to be an overcomer.

The word of God declares, *He that overcomes will I give a crown of glory.* There is a cloud of darkness over the lives of those who compromise. They are driven by spiritual influences of satanic manifestation. In doing this, one's lives will be trapped and chained to do as commanded. You are not in control of yourself. Acting violently is a clear manifestation that you are influenced to manipulate others by the twisting of your speech and the manifestation of false prophecies.

The spirit of compromising is a demonic spirit seeking residence where any void is evident or noticeable.

Thirty-Three

Boldness to Confront

One of the most frequent quotes used by prophets, prophetesses, evangelists, and even pastors is, "He that hath an ear let him hear what the spirit says to the church." According to an account of Acts of the Apostles, chapter 4, when Peter and John were taken captive by the counsel of the Pharisees they stood their ground in what they believed and were right as to the preaching of the Gospel. They maintained the truth with boldness; neither one was contrary to the other.

They both spoke with authority and were released by the authorities. The Bible says that they went back to their company and reported the matter. Upon their faith in God through prayer, they were filled with the Holy Ghost and spoke with boldness, and great grace and power were among them as they continued to do the master's will.

It takes boldness to confront the stronghold of Jezebel. Although the disciples were put to the test by the Sanhedrin's counsel, they never entertained any form of intimidation. They held their peace and allowed the Lord to fight the battle. Sometimes it is crucial to stand! After having done all to stand, stand therefore, believing God for boldness to face your nightmare—Jezebel. Note in the text that the disciples were not selfish even though they could have been, but they reported everything to the others, simply because hearing what had transpired gave them more faith to remain faithful with God.

In Timothy 1:7 Paul says,

> For God hath not given us the spirit of fear, but of power,
> and love, and of a sound mind.

Fear is one of the most popular weapons Satan uses against the Christians. He uses fear to manipulate, paralyze, discourage, and destroy our zeal, dreams, and ministries. To counteract this spirit, one needs courage to manifest boldness so as to motivate the believer to fight on, in spite of the odds and trying situation. Many pastors are weak when it comes to this crossing over. When the children of Israel were pursued by the Egyptians, they came to the point where only a cross-over miracle from God could deliver them from the noisome pestilence of Pharaoh and his armies. Moses, through having courage, assured the people to only "stand still and see the salvation of the Lord God that brought them over on dry ground."

Courage to Manifest Boldness

I believe God will grant you, my friend, courage and boldness to confront any situation. Do not panic for that is what the enemy wants to see right now, but cultivate a faith that is immunized against the spirit of fear.

The Word of God Encourages

> Be not afraid of sudden fear, neither of the desolation of the wicked when it comes. For the Lord shall be thy confidence, and shall keep thy foot from being taken (Proverbs 3:25–26 AV).

Many of God's great servants have experienced trying situations with fear. Some have walked through the valley of the shadow of death (Ps. 23:4), while others have gone through the "fiery furnace" (Daniel 3), the lion's den (Daniel 6), and great storms of life (Acts 27). Yet they have survived through the power of faith.

The Words of Nehemiah Remind Us

> Be not afraid of them: remember the Lord which is great and terrible, and fight for your brethren, your sons, and your daughters, your wives and your houses (Nehemiah 4:14).

After the man of God spiritually defeated the prophets of Baal on Mount Carmel (See 1 Kings 18:1–46.), the news came shortly after that

his life was going to be encapsulated. The mighty man of power started to panic and fled for his life as a result of one woman. He fled from the mountain to the wilderness seeking refuge. Elijah was discouraged, fearful, and wanted to quit and die. The parallel to Elijah was John the Baptist. The spirit of Elijah was placed on John the Baptist, who was again confronted by this same Jezebel, manifested through Herodias. She had him killed because he exposed her sins. John the Baptist became discouraged and fearful and sent his disciples to inquire of Jesus if he was truly the Messiah, even though he witnessed to others and had seen the Holy Spirit descending on Christ. He still wanted a second answer. (See Mark 6 and Luke 9.)

These two mighty men of God surrendered their lives at the voice of Jezebel, knowing the God they served was all powerful. The tool Jezebel used on them was intimidation (fear) so that they would be carried away, timid and losing sight of God. This was a demonic force destructively speaking to cripple their faith in God. She used fear and terror to produce humiliation on their part, hoping that it would bring dishonor and shame to God. However, this was not so; the spell, the reproach, and the defeat were rolled away by Jehovah God. The Lord Said to Joshua,

> This day have I rolled away the reproach of Egypt from you (Joshua 5:9 AV).

Jezebel is out to defile anything it touches. That which is holy becomes unholy, anointed becomes corrupted, and righteousness becomes vile.

If you are threatened by your Jezebel, do not leave your *Mount Carmel;* stand still on your mountain and fight back using the name of Jesus. The moment you run from your mount, you would have already lost the battle in your mind. And once the battle is defeated in your mind, the gateway is opened for Jezebel to enter and possession. Do not let your Jezebel drive you out of ministry and cause you to hide in an emotional cave.

Come out of your cave of fear and stand with courage and boldness to dethrone her. Jezebel wanted you to leave your mount so that she can dominate, but don't leave because it represents prayer, power, and victory. Your Jezebel cannot fight with you on Mount Carmel because there

Exercising righteous authority comes with a reward to the things we do and overcome.

lies the mighty rushing wind of the Holy Spirit. She will be confounded and confused on Mount Carmel. Her plan is to get you in a cave where she can send terror by night, arrow that flieth by day, and pestilence that walketh in darkness. (See Psalm 91.) Only in the cave she can be effective and paralyze you.

Steps to Refrain from Being Corruptly Influenced

- Discern, recognize, and then relinquish any methods of control and manipulation encountered around you—wisely.

- Dismiss any thoughts that are harmful, rather than edifying, by ceasing gossip, especially against leaders and members.

- Refrain from carrying news (tale-bearing)

- Avoid private meetings that focus on private accusations; don't be a victim of corruption; be a victor of change.

- Don't attend meetings without having proper witnesses in case uncouth behavior unravels.

Overcoming a Jezebel Spirit

- At all times display righteous authority.

- Don't be intimidated by her dominance.

- Don't compromise the word of God.

- Be confrontational with the truth and not flatteries.

- Always be prayerful before making decisions.

- Have a strong network of intercessory, dedicated. and well-seasoned people that will pray on your behalf.

Discerning the Spirit of Jezebel

- By their prayer and speech delivery;

- By their words of expression;

- By their actions of association;

- By the fruit of their calling.

The Plot of Jezebel

- Jealousy
- Accusation
- Aggression
- Seduction
- Trained psychologist
- Manipulation
- Counterfeit countenance
- Double-minded personalities
- Intention to create harm instead of good
- Subtle in investigation
- Counterfeit voices

Scoping under a Jezebel Ministry

- Maintain your composure in the word.
- Stay focused by embracing a healthy attitude of humility.
- Tear down every stronghold of imagination, past memories, and remorse.
- Live in constant prayer and fasting with God.
- Avoid pre-hurts discussions and associations that will resurface thorns of bitterness and unforgiveness.
- Guard your mind from being negatively influenced.
- Be calm in your speech delivery, greetings, and fellowship.
- Give no signals or evidence that points to rejection, hatred, and bitterness.
- Know your boundary line.
- Refrain from lying; strive to be honest when called upon.
- Know hide-and-seek personalities.
- Trust Jesus daily to take you through your gestation periods.

The Things Jezebel Hates

- Repentance—this spirit is afraid to attend prayer services that call for true repentance.

- Humility—this spirit is eager to gain a platform of precedence rather than to be submissive and accountable for the lost sheep.

- Honesty—she is afraid of the truth so she would rather compromise by pleasing everyone.

- Prayer—prayer reveals the secrets of the heart. Therefore, when you pray in the spirit, you are binding her plans and paralyzing her motives.

- Prophet—this one is her worst enemy. A prophet will speak out against her at any time so she doesn't want this ministry around her. Fire will be in the camp at all times.

- Righteousness—she hates righteous living. The word of God says righteousness exalted a nation and sin is a reproach to anyone.

Let's pray: Father, teach us your will so that we may become submissive to your standard of righteousness in all our ways. We ask for a heart like thine that is pure and holy in service to you and you alone. Dear Lord, forgive us our intolerance and impatience of our waiting.

Father, we want to submit to you so that we can have the power and authority to resist the devil; to bind principalities and powers over our lives in your name, Lord; to renounce every Jezebel spirit and stronghold of the mind through the blood of Jesus; to render the demonic fortress powerless and to nullify their place of dwellings.

Father, we thank you for marriages that are restored right now; we thank you for that husband and wife whose lives were touched by your blood. We speak divine utterances of holiness in the body of Christ and bind the terrors of fear that control the minds of your people. We therefore lose the spirit of humility and love and pull down the spirit of pride and overly ambitious imagination. In the name of the Jesus Christ. Amen!

I thank the Lord that the answer is on the way for you. Break through in Jesus' name.

Know Your Boundary Line.

Every pastor must have a red line in his or her ministry
to guard against the spirit of conspiracy.

Thirty-Four

A House of Darkness

Our deliverance team consists of five persons who were chosen by God in answer to prayer and fasting. Our mission was to dismantle, disarm, destroy, and defuse every atomic bomb of Satan by pulling down his strongholds and high principalities in high places. Our task was not an easy one, but we obediently did as the Spirit of God led. We were refueled, refreshed, and restored with new oil for each journey.

Rebecca was complaining about the different nightmares her son was having at midnight. She claimed that the house was "webbed" by the landlady of the property so she requested prayer from a fellow minister of mine. I was personally asked by my fellow minister friend to assist him in praying for this young lady. I was adamant at first, but I told my friend that I operated with a deliverance team and we would pray and fast about the situation and let the Lord direct us from here. Anyway, it seemed to be a 911 case so I went over there with my standard-bearer to see exactly what the problem was. Approaching the house, our heads started to take the shape of an inflated balloon and as we entered the door we speak the Word of God with authority using the blood of Jesus.

Let us not fool ourselves: God's eyes are on the sparrow and I know he watches me. Our own deception will one day be revealed.

Stepping into the house, we were welcomed with a cloud of darkness—"a house of legions." It was a house occupied with different ranks of demons. Demons from all different backgrounds were there. Nonetheless, we were optimistic that God would deliver us from the pawn of the lions. We sang a few songs

and then prayed, but while I was praying in the spirit the Lord spoke to me and instructed me to go up the stairs for that was where the source concentrated. At first, I paused and hesitated a little, but I obeyed knowing that was not the place to have doubts.

Going up the stairs was like fighting all the terrors of hell. It took me approximately twenty minutes to get there. I was fighting different areas of strongholds in the spirit. Climbing the stairs was like *walking in a woodland*—I had to cut my way up the stairs in the spirit.

Her bedroom was the dwelling for these schizophrenia demons. Sleeping demons were there, tormenting spirits, fear, sex, etc. were all in this room. The child's room was to the extreme left and when I entered the room three persons were lying on the bed. I rebuked that demon, but something strange happened that night. This time I prayed in my spirit by closing my eyes. The voice says to me, "When you open your eyes you will see the source." Believe, my friend, it was three of us and as I opened my eyes, lo and behold eye to eye was this woman. The very sound of her voice gave her away that night, revealing to us that she was the root cause of this battle.

Our Own Deception Will One Day Be Revealed

Later in the week, I called the young lady to see how she was doing. Her response was vague and sounded questionable so I persisted during the conversation on the phone. I told her not to entertain or do anything that will displease God in the house. Her response was, "No, Pastor, I would not do that." Then I assured her not to be influenced by anyone to do anything outside the will of God.

Thirty-Five

Personal Encounter with Demons

As a young man in my teens growing up, I had numerous battles in relation with unclean spirit where my body was permeated, drained, and weakened by these experiences. On many occasions, my body would be consumed with fire, especially when evil spirits were around. Demons are real and live in vessels. They seek to invade human beings by creating their own demonic race to overpower the kingdom of God. Literally, demons can take the form of human body to eat, live, sleep, and even to have intercourse with you. One thing we must all know is this: a demon can never enter your body without an access. There has to be a space in your life that will entertain and cater to their needs.

I was called to ministry at the tender age of nine, not knowing that the number nine is of paramount importance in the Bible. It is the number of fruitfulness, conception, and giftedness. God was preparing the seed of ministry in me at that time to become fruitful. I would envision demons and next day it would happen—I would feel my head raise, feel hot and lethargic. I would feel spirit in my bed choking me. I was inexperienced with those things happening to me but some way along the line I know that the voice of God was a guiding path to my calling. One day after going to the field to feed my dad's animals, I simply had a dialogue with Jesus by gazing in the sky. I said, "I need your help, Lord. I don't want to be corrupted." The voice spoke to me in the hot sun as I looked steadfastly in heaven: "I am going to prepare you for ministry by sending you to a bishop's home to teach you." Paul, I believe, had a mentor in the life of his ministry. Timothy and others all had great men of God that piloted them in their ministry as the spirit of God gives pre-eminent authority.

Amazingly, I was a good student at Four Pass All Age and was loved by many because of the humility and favor of God on my life. One of my favorite teachers, Miss McDonald, said that she was praying for me and she was concerned about the distance I had traveled to school so she was going to help provide accommodation closer to school. Where he leads me, I will go. My spirit bears witness to the decision. I went and to my surprise it was a bishop's home. Seen the glory of God so tangible on his life, I then perceived that he was a man of God., I could see the fire like Elijah in his eyes, and the presence of God was all over him.

The ignition of ministry began right there. At first, I lied about a few things because the old man was not crucified, but gradually, as I got down in deep fasting and prayer, my life was completely transformed.

Thirty-Six

Exposing and Defeating the Deeds of Satan in Your Life

T he word *exposed* means "to bring to light; to make known or revealing of hidden things." The five main ammunitions used in exposing and defeating the deeds of the devil can be summarized in this order:

1. The Power of Prayer

P rayer is a powerful spiritual weapon of warfare. It is mighty in pulling down strongholds. Prayer serves as a defensive as well as an offensive weapon against the mechanism of Satan.

The power of prayer is so effective worldwide. It is the only missile that yields valuable results when launched in the spirit. It can be directed from all over the world to meet the needs of others.

2. The Power of Fasting

This kind cannot come forth by nothing, but by prayer and fasting (Mark 9:29 ; cp. Matt. 17:21).

F asting is one of the foundation pillars of the Christian faith. It is a mighty weapon of spiritual warfare. In fact, fasting is a spiritual companion of prayer that increases the level of our faith to receive from God. It's also a scriptural means of receiving, keeping, and increasing the anointing. It is through this channel that yokes are broken, men are set free, bonds are loosed, and heavy burdens are lifted. Jesus taught his disciples the importance of fasting in essence to spiritual encounters with demons.

This was seen in the gospel of Matthew when they came in close battle with an unclean spirit; the disciples were lacking faith and the anointing to confront this demon. The question was posed by the disciples: "Why could not we cast out this demon?" (Matt. 17:20). The Lord answered: "because of your unbelief ..." Jesus was simply saying to the disciples that if they endured a little more fasting and prayer, their faith and anointing would increase, giving them the power to cast out the demon.

The power of fasting would have exposed, dismantled, disarmed, and destroyed the yoke. Fasting not only exposes the deeds of the devil, but it also subdues the desires and lust of the flesh, making a barricade around the believer and elevating oneself to a higher place in God. The depth of God's revelation is found in surrendering to fasting and prayer (fasting without prayer is starvation), which enriches and make our spiritual life more meaningful and purposeful. There are some things that will not be revealed in prayer alone but with the combination of both. The "deep that calleth to deep will be evident. (See Psalm 42.)

The surface of God is prayer-devotion, but the depth of God is fasting and prayer-consecration. For the body of Christ to stage a final combat on every domain of the devil, the dynamo of fasting must be filtered thoroughly through every mainline Christian regime. The church will never be effective if this main source of power is missing and even so lacking. Let us not fool ourselves. The wiles of the devil are to destroy every single living cell along with all tissue, organs, and systems in the body of Christ to deactivate the functioning, thus creating confusion and less spiritual energy in the body. I believe we, the church, need to wake and trim our lamps for the battle is on.

The songwriter penned the lyrics "Onward Christian soldiers, marching to war with the cross of Christ." The cross bears the seals of Christ's triumphant victory over the enemy. For the church to march to war with the cross, we must have strength and energy to carry it. This energy and strength will have to come from fasting and prayer. Fasting fuels prayer and is a catalyst that speeds up its rate, giving prayer supersonic wings. Renewed energy and power come from fasting to such an extent that a high level of faith and spiritual gifts are released when one prays. It releases the faith that moved mountains, obstacles, doubts, and fear. Fasting provides one with greater authority to exercise more spiritual power over the devil. Jesus spoke to the devil with dynamite

authority because of the forty days and nights fasting he was on. He conquered and defeated him.

In the same chapter of Matthew, we see where Jesus again had to rebuke and command the demon to leave the lunatic boy alone. Prior to that same event, the disciples had some measure of power to cast out demons, which they successfully achieved, but they were not able to handle this case of the possessed lunatic. They tried every note in the hymnbook, but could not cast out this fearless one. What was lacking was the power of authority. Jesus made it very profound to his disciples by saying, "In my name they shall cast out demons." At the name of Jesus, every knee will bow and confess. Did this demon bow and confess? The disciple instead had to "bow in defeat."

The father of the lunatic then brought the child to Jesus and pleaded for mercy, according to the text of Matthew 5. The father, I believe, knew the authority that was bestowed in Jesus. With the power of authority, Jesus rebuked and commanded the demon to go out and instantly it obeyed. The disciples were ashamed so they went to Jesus privately to enquire. Jesus explained to them further in verse 20, the result of their failure.

The lesson our Lord is trying to impress on us is that this particular kind of demon cannot be handled like the ordinary kinds of demons. This demands faith-fasting and prayer. In other words, there are high levels of principalities out in the world awaiting the saints, and the best of the best and fittest of the fittest will survive to conquer the chain reaction of Lucifer.

Genuine revival will only come when the church gets back to the old landmark of fasting corporately and collectively to their first love. Throughout the Bible, we have seen great men and women set aside designated days to seek the Lord for the succession of leadership for the direction of decision-making and for the assurance of victory. The call to fasting and prayer has rendered kings, queens, enemies, and even Lucifer powerless, thus demonstrating the awesome power in fasting with prayer. It can work for this present-age church if we sanctify our bodies by renting our garments, weeping continually, wailing, and bonding our bellies for our nation. By doing this, my friend, we can experience the blessings of supernatural power to do great and greater exploits. (See Luke 4.) The gifts of the spirit will be in full operation (Dan 1:18–20). The revelation of

mysteries (Dan 9:3–27) and the knowledge of God's power will edify, glorify, and equip every born-again believer for this mandate.

The word *fasting* is translated from the Greek noun *nesteia*. It is made up of two compound words: *ne*—a negative prefix meaning not—and *esthio,* meaning "to eat." Thus *fasting* means not to eat, staying away from solids and liquids for spiritual purposes, according to 1 Corinthians 7:5. This allows the inner man to be elevated and the desire of the flesh to be conquered.

The word is the foundation of Christian authority. It is the basis of our faith in God through Jesus Christ, his son.

Fasting replenishes our body and intensifies our hunger and thirst for more of God.

The songwriter says, "Let me lose myself and find it all in thee, let all flesh be slain, my friend." Our inner man will be filled with the oil of joy, the well of God's spring, and rain from above.

Fasting gives you more:

- Boldness for confrontation;
- Authority to speak;
- Power to energize you for battle;
- Enrichment for our spiritual soul and more of God's grace;
- Beautifies you with more grace and humility;
- Subdues the lust of the devil;
- Reveals and exposes more the deeds of the devil.

3. The Power of the Word

The word of God is our offensive weapon of spiritual warfare that we use to engage the devil in battle. It is the ammunition for our rifles that we use to fight principalities and powers in high places, by faith in prayer and by the anointing of the Holy Spirit. It is the avenues through which we legally exercise spiritual authority over the forces of darkness and overcome them.

> And they overcame him by the blood of the lamb and by
> the word of their testimony … (Rev. 12:11).

There is nothing more powerful and irresistible than the word of God. Life has been transformed by the awesomeness of the power of the word of God, demons have been rendered powerless, and victories have been won using the word of God.

The word is the foundation of Christian authority. It is the basis of our faith in God through Jesus Christ, His son.

Satan was rebuked on many occasions by Jesus and his disciples by the word of God. It is the armor of every child of God for warfare. Since the word of God is omnipotent, therefore it means that God is omnipotent, which collaborates with the divine revelation given to John in the Gospel of John, chapter 1. The living word is the *Logos* of God, manifesting his co-eternal attributes in relation to his deity and creative power.

The significant injunction of the word when spoken concerning a specific situation becomes "the sword of the Spirit," "live coal," utterance of the spirit and "violent," is called Rhema, bringing more edification and transformation to the body of Christ through the spirit of illumination. Logos is the word, or reasoned speech of the word. *Rhema* is the utterances of the Spirit spoken into a particular situation that brings total transformation and justice. It is the articulate expression of a thought that is beneficial by edifying the body of Christ to the glory of God. It is given only by the Holy Spirit of God to individuals who are available. The *Rhema* word is not the whole Bible as such, but inspiring Scripture from time to time that the Holy Spirit brings to our remembrance for use in time of need.

Nothing stands like the word of God. It is my daily meal that keeps me going. Many of my friends often wonder why I was more mature and spiritual as a young Christian in the Lord. I told them, "The secret is staying in the word." (See John 15.) Written in the word is everything to solve our problems. In the word, there is life, there is power, there is salvation, and there is victory. Nothing can hinder the power when spoken in faith and authority.

All of the spiritual battles that I encountered during my tenure at Bible College and on mission trips were won using the word of God to defeat the power of darkness.

Don't worry about the fiery dart that you are facing, don't forget to use the word in faith with the power of the Holy Spirit. Remember the word is our defensive and offensive weapon in spiritual warfare. The word is our sword, an instrument of warfare. (See Hebrews 4:12.) We use it to cut off the heads of our Goliath in battles. (Other references on the word are in Rev. 2:12, 16; Isaiah 11:4; and 2 Thess. 2:8.)

The word is irresistible. When spoken with the anointing, nothing can stop the effect of it. It availeth much and yield great results. "So shall my word be that goeth forth out of my mouth: it shall not return unto me void, but it shall prosper in the things whereto I sent it" (Isaiah 55:11). Speak the word and command it to your situation, and you will see the effect that it will have on your life and family. The word travels to places, but we have to send the word in faith to the problem you are having in your marriage, finances, and children. The word of God says, "Life and death are in the power of the tongue" (your mouth). Job also says, "Thou shall declare a thing and it shall be established."

I strongly believe the devil defeated us many times in our knowledge and understanding of the word of God and is one reason we are not getting the breakthrough. The word is not in the mind. The word is not in the spirit. It is in the ghetto of our attitudes toward God in our devotions (He is not in the picture of outlives—preoccupy?).

The word is our hammer. (See Jeremiah 23:29.) The word is like fire. (See. Jeremiah 5:14.)

Battles cannot be won by mere prayer and fasting. The word, with prayer and fasting, is the blueprint to victory over and beneath the powers of darkness.

4. The Power of the Blood

This is the mark of Jesus that covers us from the wiles of the devil through which we overcame him. It is the protective seal that differentiates his people from the sinners. (See Rev. 12:11.) It is our life insurance that carries no expiration date but guarantees salvation and protection.

Man's redemption from sin was made possible through the death of Jesus Christ on the cross and resurrection from the tomb. He was ascending to his Father and there presented the blood, which was the token

of redemption. The blood was then sprinkled around the mercy seat of God, signifying total victory over Lucifer. (See Hebrews 9:11–12.)

I believe an exchange took place in heaven when the Father accepted the blood. I believe it was there that "the gift of the Holy Spirit" was given to Christ to pour out on the church. (See Ezekiel 39:29.)

The power of the blood speaks of the power of the Holy Spirit. The high priests were anointed with blood to serve God. It is the power of the blood through the anointing that enables us to minister effectively (Exodus 40:15).

The blood was applied by the priest three times a day to anyone who had sickness. In the case of the leper, the blood was applied to specific areas of his body, which is very symbolic even to us today. First, the blood was placed "on his right ear." Second, it was placed on "the thumb of his right hand." Finally, the priest applied the blood "on the big toe of his right foot" (Lev. 14). The application of the blood was for the cleansing of the leper's ear, hand, and foot, but there was more to this revelation. This was a cleansing anointing procedure carried out by the priest. Sprinkling of the blood was always done with oil as recommended by God, so as to manifest his glory when descended in the tabernacle. The sacrifices then would be consumed with the fire of God in the form of pillars of clouds resting over the house of the tabernacle. Where the blood is applied, you will find also the anointing of the Holy Spirit.

As Christians, it is important that our ears, hands, and feet are cleansed with the blood and anointed by the Holy Spirit.

- When the blood is applied to our ears, our hearing will be shielded from the voice of the enemies and be better alert to know the true voice, and with the anointing we will hear the Lord's voice (John 10:27; Ps. 55).

- Our hands represent the work of God that we do and so we need them to be anointed so that the devil cannot touch our work, business, etc.

- Our feet are symbolic of our daily walk with the Lord, and with the anointing our steps will be ordered by the Lord in light and not in darkness (Ps. 1; 1 John 1:7).

God wants to cover us from head to toe with his blood and the oil of the Holy Spirit so that our lives can be completely hidden in Him.

5. The Power of Praise

The anointing through the spirit of praise is very powerful, which enables one to exercise spiritual authority and confidence in battle. Praise is a weapon seen throughout the Bible and it is used in many ways to defeat the enemy and bring glory to God. The power of praise comes with a force that can only be discerned by the person and understood by God. In the Bible, many victories were won through praising God.

The Assyrian army against Jehoshaphat according to (2 Samuel 8:16; 1 Kings).

The army of Israel is noted to begin battle with praises and to end in battle victories with praises. This is very significant because, each time praises are offered, the host of heaven releases "an angelic host," as connoted in Psalm 46, to fight the battle. The Lord of hosts is with us and the God of Jacob is our refuge, saying that by praising God, you are inviting the *Lord of hosts to take refuge.*

Thirty-Seven

The Shadow Anointing

The shadow of the anointing can be exegetically seen in Psalm 91, which says that He that dwelleth in the secret place of the most high shall abide under the shadow of the almighty. He will cover thee with his feathers—the protection of the anointing. There is a projected secret place in God where you are comprehensively covered from all demons. This covering can be illustrated by the analogy of a chicken under the wings of her mother. The mother covers its young one from impending danger of the hawk or eagle that seeks to devour it. In so doing, the mother forms a layer of covering and a barricade around her children where they are not seen by the predator. This covering is also in Christ; we are hiding under the wings of God's light.

The devil only can see the blood and not us. The only way he sees us is when we are exposed to darkness and not to light. If God moves his hands for a moment, then the devil will have the access to intervene. The Bible says the devil is like a roaring lion. Note he is not a lion, he just roars with intimidation to frighten and get you confused and fearful. The devil has to seek around simply because of his limitations. This shows us that he is limited to excel and is not omnipresent. Our God is all-powerful, mighty in battle, and victorious in war. He triumphs over every darkness and leads the captive out of captivity led captivity captive. Isn't God mighty? The devil is defeated once and will again be defeated and bound forever.

The shadow of the anointing will expose you; it will reveal you as you operate under the gifting. Job was not exposed to the devil; the Lord revealed him to Satan. This classical example is projected in the life of Job. (See Job 1 and 2.)

The anointing hides you from the wiles of the devil. The devil could not locate Job, which shows us that he was hiding in the cleft of the rock of Jehovah. He was overshadowed by the presence of God and his angles. The devil went to and fro looking for a perfect man and did not find one. Nonetheless, he was courageous enough to go back to God, probably mocking God, not knowing that there was a man by the name of Job that he never saw in his search for a vessel of honor unto God.

Don't care how crafty the devil may think he is; he is powerless to the infinite power of God. He is no match to the anointing that God has given to you and me; we are God's agency here on earth, and no demonic stronghold can break the bar of the anointing to do us any harm. Job's whole life was completely barred around with parameters—the angles of the Lord encampeth around us that fear him (Ps. 34). The devil did not see Job simply because of the anointing that shaded him from the devil.

ഇ)ങ

He hideth my soul in the cleft of the rock that shadows the dry thirsty Land.

ഇ)ങ

As mentioned before, the glory of God can transform you to the point where you are transfigured in the shining light of God. The luminous glory around Job blinded the eyes of the devil. Light, when projected directly at you, will cause different images to illuminate and appear real. Your eyes will have to adjust to the focal rays of the intensity of the sun's light.

Words of Comfort

Tell yourself, *I am covered with the blood of Jesus and I am under the shadow of the Almighty.*

The Shadow Anointing of Peter

Peter was no doubt caught in the realm of God. His life was a failure in the beginning, but when he was converted and anointed on the day of Pentecost, he was never the same again. He became a mighty warrior and a stronger tool in the hand of God. As a result of this drastic change, his first sermon convicted three thousand souls to the kingdom of God. Moving from glory to glory, he was transformed to another dimension in God. His very shadow healed and set lives free.

Thirty-Eight

Know the True Power:
Be Armed with Knowledge

Many shall come in my name and do great wonders saying that he is Christ (Matt. 24). The knowledge of the anointing is through the infallible word of God. This can only be applicable by studying the word, thus acquiring knowledge to face and challenge your greatest fear. To also expose the darts of the devil, one must be fully equipped with the knowledge of the word of God, for at the end of the day, when all is said and done, it is the *rhema* word we have to apply to defeat the strongholds of the enemy. By gaining this comprehensive knowledge, one will be more equipped and spiritually armed.

The Greek word for knowledge is *gnosis,* which means "to know well." We cannot engage in something that we are not aware of; there should be some hint or experiences. The word of God declares in 2 Peter 1:5–10 that knowledge is Christian virtue that leads to perfection in Christ. Knowledge also is power. The devil knows that once we are cognizant of the facts, we will know the truth and the truth will set us free (John 8:32). For the knowledge of God's word will give us wisdom and liberty, according to Dr. Christopher.

The power of the anointing is through the word of God and in many cases battles are won by praising God—the knowledge of the word. This in return acts as a guiding light to go deeper and higher in God. Identification of spiritual warfare is only achieved through the knowledge of the word. Thy word is a lamp unto my feet and a light unto my path.

As a result of this illumination by the Holy Spirit, Lucifer is now launching his schemes to counterfeit God's all-powerful knowledge. This

antidote is spreading so vicariously in the system of the body, causing metabolic reactions to the truth and side effects to the leading of the Holy Ghost. In all of this, however, the body of Christ is getting more spiritually advanced in producing more antibodies (power) to defend and to destroy the *nuclear atom* of the enemy.

The more knowledge the body gets, the stronger it becomes and accelerates in growth. Daniel the prophet conveys this consolation of hope in 11:32: "But the people who know their God shall be strong, and do exploits." The devil at this very moment is afraid of you moving up the ladder in life, but I command all jealous spirits of Jezebel to hold their peace concerning your purpose and achievement. God says to tell you, *Yes! You will not only get knowledge, but knowledge to be stronger and do greater exploits in all your endeavors. You will know the truth and the truth will set you free.*

I am speaking to you right now, as you read this book. The wind of the anointing will definitely enlarge every domain and border in your life.

The spirit of God tells me that you have been suffering to break out of the box of limitation to do greater exploits, but you have been deceived by his cohorts many times. Now, says the spirit of God, you are set free and loose. No more limitations. Instead, there will be an overflow of God's extension of knowledge. Grow, my child, the devil is just defeated!

Knowledge is a weapon and a defense used in the faculties of life's achievements.

Solomon writes, "A man of knowledge increaseth strength" (Proverbs 24:5b). Having knowledge is like holding half of the future in your hand. Therefore, if you have knowledge of the word, half of your circumstances are granted, half of the battles are won. You must at all times know that God is able to do exceedingly and abundantly above all we can ask for. To know is a wonderful thing. Most people are defeated simply because of ignorance.

The apostle Paul was the one that concluded in his epistle of joy and love, "That I may know him and the power of his resurrection and the fellowship of his sufferings, being made conformable unto his death" (Phil. 3:10). A burning desire to know God gives you and me the needed tools for spiritual warfare. The word of God reveals,

> My people are destroyed for the lack of knowledge:
> because thou has rejected knowledge, I will also reject
> thee, that thou shalt be no priest to me: seeing thou
> hast forgotten the law of thy God, I will also forget thy
> children (Hosea 4:6).

Ignorance is a spirit that breeds contention, darkness, strongholds, fear, and failure, but knowledge breeds consolation, light, truth, courage, and confidence.

Ignorance will destroy you and make you feel rejected if you are not keen to the wiles of the devil. "Be vigilant and sober ..." Knowing the true power of God, one must possess soberness of mind and watchfulness of spirit.

One of the most powerful weapons that is little taught in the body of Christ is knowledge. Pulling down of strongholds, casting down every imagination that seeks to exalt itself against the knowledge of God is least to mention in the church, but with this tool in ministry you will know that our weapon of warfare are not carnal. (2nd Corinthians 10:4).We will know that we wrestle not against flesh and blood but against principalities and powers and we will know that greater is he that is in me than he that is in the world. The power tool to do greater exploits is knowledge in the word.

Knowing the true power of God has to do with having an intimate relationship with God, thus "but the people who know their God do greater exploits." This relationship comes through the act of prayer and meditation on the word of God. Many people don't realize that all of David's missions to battle were successful based on him having a personal relationship with God through the pathway of knowledge. David was knowledgeable against the odds of Goliath. "You came to me with sword, but I come to you in the name of Jesus" (2 Samuel 17). His knowledge-relationship led him to the brink of the river where he only took up five smooth stones.

He was directed and did according to the command of the spirit of God. David was victorious and Israel defeated the army of the Philistine. Our desire is to be like the hart of Psalm 42, and to imitate Philippians 3:8. The knowledge of God is the source of your strength. Knowing your God is the secret chamber to the tabernacle to experience the *presence of the ark.*

The Knowledge of the Word Caused Us To

- ○ Know our God;

- ○ Know our enemy;

- ○ Know ourselves.

The knowledge of God makes one wiser in the sight of God and most definitely when battling with spiritual warfare. Knowing your enemy is to study his tactics. The enemy is a strategist. He uses our spoken words to formulate his ideas and plans to psychologically defeat our dreams. We must at all times strive to remain in the spirit, so that we may know our strength and weakness. The knowledge of the word tells us that he is defeated and will be again, for our sake (Col. 2:15).

Thirty-Nine

Witchcraft in the Pulpit

Those that are "deep calleth unto deep." Children of God will understand this revelation. We will be surprised to know the amount of spiritual witchcraft working in the pulpits of some of the top-class churches. As earlier stated, witchcraft is the appearance of overt manifestations taking a more discreet demeanor with subtle background personalities. Pulpit syndrome (having a love for the pulpit at all times) is a great factor in the churches today and is spreading like wildfire without any control.

Pulpit syndrome is linked to spiritual workings of witchcraft in the body of Christ (malice and hatred). The anxiety, coupled with a great sense of pride, is one of their hidden agenda waiting for the perfect timing to surface. The Lord says their motives are deeply supplicated with creative ideas, vision, and most definitely rebellion.

Now the uncouth behavior that is evident in the pulpit can be seen as witchcraft mainly because the emotional patterns speak volumes to you. The transferring of thoughts that misguide and lead the people astray is also considered as witchcraft.

Witchcraft in the pulpit is basically satanic influence of powers in that He is imposing his will on your will to impose the same on others. The wound from the pulpit, cursing and throwing of words "stone" is deletelinked to satanic powers.

I have encountered many people I thought were on the ship but as soon as some mishap transpired you discover who your best brethren were. Persons like these strategize behind the scenes and at the end of the day they pretend as if nothing is happening.

Witchcraft in the pulpit is mostly acquainted with the head of the church. The head represents the main stream of the river and if by any chance that main stream is infected, the river will also be affected. Family inheritance can also be a factor in all of this. I studied church history at college and when you investigated the birth and parental background of these churches and family in general, then you began to understand the order that God outlined for the children of Israel to abide by. Parental headship can cause more damage than restoration to the church, and this is why many family churches to this day are still in disarray, disorganized, and dysfunctional.

There is no need to fight over the next in line: Joshua. There is no need to work up a sweat over church work. If God calls you, then he will provide you with the vision and equip you for the task. Be yourself and let God promote you to the top of the stream.

What Is Spiritual Witchcraft?

- ❖ Spiritual witchcraft is the root of rebellion and stubbornness (1 Sam. 15:23).

- ❖ Spiritual witchcraft is imposing seducing thoughts, emotions, and behavior on people one would not have liked otherwise.

- ❖ Spiritual witchcraft is self-gratification and not God's glorification to be seen and heard.

- ❖ Spiritual witchcraft has the power and ability to corrupt but cannot control such individuals.

- ❖ Spiritual witchcraft is fueled by bitterness, resentment, and judgment without the spirit of forgiveness.

- ❖ Spiritual witchcraft is the works of the flesh manifested in evil power (Gal. 5:19–20), and all believers can be exposed to it.

- ❖ Spiritual witchcraft is paying a blind eye to the truth and pretending as if it is not there (Gal. 3:1).

- ❖ Spiritual witchcraft is disobeying legitimate authority by becoming rebellious (Gen. 1).

Knowing Spiritual Witchcraft

- Manipulation—the desire to control, covert ways;

- Domination—the ability to make you do things, convince, rule over, and dominate (1 Kings 16–18);

- Intimidation—the casting of fear, demonic influence, opposing forces (1 John 4:18).

Appendix A

The Strongholds of God

The word *strongholds* when translated from the Bible in Greek and Hebrew means "refuge, security in God, defense and protection." It is also used interchangeably when referring to the "hiding place of God," or "secret place" as in Psalm 91. In light of that, when speaking of spiritual warfare, *stronghold* is enlisted as "principalities in high places." In that same breath, the apostle Paul enlightens our knowledge on this same word by quoting from 2 Corinthians 10:3–4. Therefore, we can safely conclude that a stronghold is a source of protection from the enemy as well an ultimate area of our life that is influenced by systematic thoughts toward evil or good.

ഔറ

Humility of the mind
precedes repentance
to deliverance
then healing.

The Strongholds of Satan ഔറ

A stronghold is that area of your life where darkness is prominent over the light of God. It is that unregenerate thoughts that is germinated in the mind, being lustful, prideful, rebellious, and disobedient to the power of God. In cases like these, we always find people that are usually possessed or oppressed by this spirit of occultism, because the mind is tormented by various fears, unsettled thoughts, or past hurt. This is why it is vital to strive for perfection in Christ by attaining the mind of Christ, because the mind of Christ means humility. Humility of the mind leads to repentance and repentance leads to deliverance. Many Christians are still bound in this chain of stronghold, though they are saved but not delivered. When deliverance takes place, it means that the complete man is also delivered so that the mind will be humbled to the

principles of God. The Bible clearly said it, for the weapons of our warfare (mind) are not carnal but mighty in God.

The stronghold of God is a source of protection from the wiles of the devil and his cohorts. Likewise, it is a network of different hedges built around us by God. Job in like manner was in the stronghold of God, and, as a result of this, the devil who thought he was all powerful could not even find him because Job was divinely hidden in the uttermost part of God, under his wings. The Bible states this very fact in Psalm 91:3: "He covers me with his feathers and under his wings." When you are under the banner of God, no *demonic oppression* can attack your mind. In like manner, the word *stronghold* can also be used as a source of protection for the believer in Christ (Psalm 18:2).

Its Counterfeit Meanings

- Stronghold is a demonic refuge of the enemy that governs your thoughts from good to evil.

- It is an envious spirit that envelops in the mind of Lucifer working against the body of Christ.

- Strongholds walk after the flesh, fulfilling its desires that bring glory to self-exaltation.

- It is a spiritual force that governs our behavioral pattern at home, churches, and communities.

- A stronghold is a system of *homemade* thoughts that can never be seen by the one committing the act.

- It is an unregenerate thought that seeks refrain from the truth, supporting lies instead.

- A stronghold is a spirit that is quick to make reference without having the facts straight.

- A stronghold is a monster within seeking to come out to light of God but is afraid.

- A stronghold is spirit that seeks to exalt itself against the knowledge of God's power.

- A stronghold is a processional thought that is rooted mainly in rebellion.

- A stronghold is a very controlling spirit that is vulnerable.

- A stronghold is any area of your life where darkness is over light.

- A stronghold is any habit that exhibits the character of the flesh.

- A stronghold is an immature way of thinking that always gets you in a circle of defeat.

- A stronghold is that unsanctified attitude that is open to unclean spirits.

- A stronghold is a spirit that breeds in contention.

- A stronghold is a carnal nature pampered by the pride of life.

Appendix B

My Thoughts Are Not Your Thoughts

In the arena of demonic strongholds, there are two thoughts at war: the thoughts of God and the thoughts of self through the mind. The thoughts of God are pure, leading you to the path of righteousness for his namesake. The thoughts of the mind are self-deception and therefore, contrary to the will of God. This thought pattern is defensive to the doctrine of God. God told Jeremiah, "My thoughts are not your thoughts neither my ways are your ways" (Isaiah 55:8).

I always tell people in class that where there is too much darkness, bacteria will reproduce. Most bacteria reproduce in areas that are without light. They multiply faster and better by feeding on the micro-saps that the naked eyes cannot see. Many Christians do not believe that; they can be deceived and used by the devil. The nature of self (flesh) will not be thoroughly martyred until the final battle with God and Satan. Therefore, we are prone to failure even when we have the Holy Spirit, which is why the apostle Paul commissions us to walk daily in the fullness of the Holy Spirit. I know many of you have seen Christian believers possessed with evil spirit(s), and you question such manifestation then and there. *Why?* It is strange to you, but not to me. Let me say this to you that are reading this book.

Any domain of our life that is not confessed and surrendered to the name of Jesus Christ is a door open for evil residence. The enemy cannot enter a house where there is no opening. He will try to break in, but you will be aware and thereby stop him right there and then. If we don't pull down these strongholds in our life, they will one day manifest and even bring you to shame. Jesus is our perfect example to follow.

Confession Is Good for the Soul

The devil works faster and easier when our mind is habitually occupied with *attitudes* and *thoughts*. This gives the devil ample time to calculate the areas of vulnerability in our lives. At times, many of us love to say, "That's how I am." But we are getting it wrong here. Think again, my friend. These little areas are dwelling places for a spirit to live in.

You may not agree with me, but I know this for a fact: spirits frequently occupy a person's life with attitudes. We must be keen to the wiles of Lucifer. Christians must have a clean spirit at all times so that the devil cannot have the upper hand over you. Satan had nothing in Jesus.

Many believed that once you are under the strongholds of God you cannot be deceived. On one hand that is true, but on the other hand the very fact that we introduced such thoughts is already the act of self-deception. The enemy permeates the mind with immature thinking and on that basis the armor of God around your mind starts to dissolve bit by bit.

Overpowering the Spirit of Strongholds

* Taking every thought captive through the obedience of Christ;

* Be still and know that God is in control;

* Speak less when confronted with people with this type of stronghold;

* Try to win fewer arguments;

* Try to be calmed as a dove and harmless as a lamb;

* Display the fruit of the spirit;

* Use the password—which is the Blood of Jesus the blood of Jesus—at all times;

* Attack the spirit that is energizing the persons in soundness of speech, rather declaring it in your spirit;

* Don't give away the ball; it is in your court so play skillfully by discerning his or her motives for coming at you;

- Apply the peace of God, which will prepare you in the presence of your enemy.

Many of our inner conflicts are not going to cease until the character of Christ Jesus is formed in our hearts.

CONCLUSION

Be Still … and Know …

I am confident and well assured to be still when it comes to spiritual warfare in high places. All God wants from us is to be knowledgeable of his promises concerning our lives. All he wants from us is to construct a platform of faith on his precedence, and by doing that then we will see the salvation of the Lord God in operation. God stilled Moses in the eyes of Pharaoh and let him know that He was in control. Only be still and know.

What God is saying, this is to be still and know that he is God and God alone. With him, all things are possible.

When engaged in spiritual battles with the enemy, co-workers and fellow associates, just be still and know. The stillness of the anointing will destroy his (the devil's) captivating thoughts.

- Be still and know that God is able to do exceedingly and abundantly in the dark cell of your life.

- Be still and know the battle belongs to the Lord. You don't need to fight in this battle.

- Be still and know that the best wine is kept for the last and it is for you.

- Be still and know that the best is coming very soon in life.

When you are up against the spirit of Jezebel, all you have to do is be still and let the God of Elijah do his work.

God is our refuge and strength, a very present help in trouble

Therefore will not we fear, though the earth be removed, and though the mountains be carried into the midst of the sea;

Though the waters thereof roar and be troubled, though the mountains shake with the swelling thereof;

There is a river, the streams whereof shall make glad the city of God, the holy place of the tabernacles of the most High.

God is in the midst of her; she shall not be moved: God shall help her, and that right early.

The heathen raged, the kingdoms were moved: he uttered his voice, the earth melted.

The Lord of hosts is with us; the God of Jacob is our refuge.

Come, behold the works of the Lord, what desolations he hath made in the earth.

He maketh war to cease unto the end of the earth; he breaketh the bow, and cutteth the spear in sunder, he burneth the chariot in the fire

Be still, and know that I am God: I will be exalted among the heathen; I will be exalted in the earth.

The Lord of hosts is with us; the God of Jacob is our refuge

Psalm 46 is for you, my friend.

THE TESTIMONY

Our Son, a Purpose Child

> God told Jeremiah that, "Before I formed thee in the belly I knew thee: and before thou camest forth out of the womb I sanctified thee, and I ordained thee a prophet (preacher, teacher) to the nation" (Jeremiah 1:5).

Our son Dwayne (prior to becoming Pastor Merits Henry) has been a menace to the kingdom of hell. He was called to minister from the tender age of nine and was mentored by the honorable Bishop Carl Wilson. We knew that this child was God-sent and considered him to be a Jeremiah and a Samuel all in one. On many occasions, the devil tried through different principalities and powers to abort the purpose of this child, but each time he tried, God always had a way of escape for our son.

Pastor Henry grew up in a family of five with a remarkable story surrounding his birth. His mother was demonized by spiritual wickedness in high places while he was in his mother's womb. On numerous visits to the doctor, she was told that the only possibility of life was to kill the child or herself. Mrs. Henry, the rest of the family, and even her church folks all gathered together, storming the gates of hell at their home for months believing.

As the day of procreation drew closer and closer, the Lord spoke to Bishop Chambers and Adonijah Henry (Pastor Henry's father) that this child would be the chosen one to break the curse and satanic powers off the family. This was a divine prophesy sent from God as the battle for life or death continued in the mind of his mother, Mrs. Henry.

One glorious day, while his father was at Chapleton working in the orange field, he was visited by the Lord and told to name the child *Merits*,

for he will be the chosen one to bring deliverance to the family, and he will live and not die. Straight away Mr. Henry hearkened to the voice of God and did as God commanded.

Mr. Henry immediately left what he was doing and headed for May Pen Public Hospital (located in Clarendon, Jamaica) to report the good news to his wife and the doctors. As the clock was ticking, the devil thought that he was getting closer and closer to victory over the doctors at the hospital. The doctors all came to one conclusion—put Mrs. Henry to sleep so that they could take the child's life to save hers. But while man was planning, God was also wiping working out His plan. Their purpose came to fulfillment that day.

The seed of the woman shall bruise the heel of the serpent! Praise the Lord! The heel of the doctors and Satan were defeated by the blood of Jesus. The operation was halted as Mr. Henry came on time and spoke under the anointing with great hope from God as he instructed the doctors not to take the child's life. Mr. Henry also revealed that "The Lord said to name the child Merits, for he is a special child and he is going to live."

The confirmation of God's word was true as it circulated far and near in the community of Thompson Town ... Yes! "This child will be the one to lead the family in the years to come." According to Mr. Henry's family.

Hence, Merits Henry was born despite the powers of hell, graduated from Vere Technical High, did part-time studies at Kingston Technical, and later attended Bethel Bible Collage in Mandeville, Manchester.

He was really a Samuel. "Been there and done that!" would be one of his favorite sayings. From grass to grace was his environment, but the Lord delivered him even when we thought that was the end of him.

Pastor Merits is the father of three beautiful children, and his queen is Rashemia Henry. They have been happily marriage for six years and still look with great hope to continue to shine brighter and brighter in spite of the storm.

He has been through so many storms in life as a young man, but God has seen him through those rough times with us.

By Adonijah and Delpha

(Mom and Dad)

BIBLIOGRAPHY

Bloomer, George G., 1963. *Spiritual Warfare*—Rev. and expanded ed. This is War (Whiter House 2001, 2004).

Christopher, Dr. G.A. *Dynamic of Spiritual Warfare* (president, International Ministerial Bible College, Agege Lagos, Nigeria, West Africa).

Ibid. *Power through Prayer and Fasting*.

Godwin, Rick. *Exposing Witchcraft in the Church* (Chrisma House, Florida, 1997).

Habershon, Ada R. *Study of the Types* (Kregel, Inc., Grand Rapid, Michigan, 1997).

Jackson, John Paul. *Unmasking the Jezebel Spirit*: Forward by Lou Engle. (Stream Publishing House, North Sutton, 2002).

Munroe, Myles. *Rediscovering the Kingdom* (Destiny Image Publisher, Inc., 2004).

Nelson, Turnel. *The Church, a Mystery Revealed* (Pneuma Life Pub., 1994).

Parsley, Rod. *The Double Portion Anointing* (Result Publishing, Ohio, 2002).

Parsley, Rod. *No More Crumbs* (Creation House, Lake Mary, Florida, 1997).

ABOUT THE AUTHOR

Pastor Merits Henry is the visionary leader and senior pastor of Worship Conference Ministries, Grand Cayman, with his wife, Minister Rashemia Henry. His ministry was birthed in his spirit at Bethel Bible College in 2001 while he was pursuing a post-graduate degree in theology with a minor in counseling. Under his dynamic and prophetic leadership, Worship Conference Ministries has become a spiritual beacon at the local and national level.

Pastor Merits Henry was born in St. Catherine, Jamaica, to Mrs. Delpha Henry and Mr. Adonijah Henry on March 24, 1981. He experienced the call of God at the tender age of nine and began preaching when he was only fifteen-years-old at the Inter-School Christian Fellowship (ISCF) at Vere Technical High School and Kingston Technical High School.

He was later appointed by the clergy as a youth minister at Good News Release Center, Prophetic Church of God, Love Lane Jamaica, under Overseer R. Howe and Bishop Carl Wilson. He was ordained and consecrated for ministry by Bishop Wilson (his spiritual father), and Dr. Christopher (his spiritual teacher). In addition to his commitment and anointing, he willingly served as their Sunday school superintendent, Sunday school teacher, men's president, and youth president.

Under the inspirational leadership of Pastor Henry, Worship Conference Ministries has become one of the fastest-growing churches in the Cayman Islands. This ministry has given tangible support to more than three organizations.

Programs are available at Worship Conference Ministries that meet the needs of the congregation and the community. Pastor Henry is also actively involved in other devotional and teaching exercises at schools and government departments of the Cayman Islands.

In addition to his full-time ministerial duties as senior pastor, Pastor Henry is also the assistant field director of Gospel Crusade Ministerial Fellowship (GCMF) Grand Cayman, whose head office is located in Bradenton, Florida. He is presently the host of sweet hour of prayer and movement of inspiration as their "Prayer Pastor" on Love 103.1, your power station of the Grand Cayman Island that is currently reaching millions of homes across the Caribbean and the world, both secular and Christian, networking by way of new media technology.

Pastor Henry has had the opportunity to play a leading role in many churches locally and internationally, but remains obedient to the vision given to him by God. He is a dynamic preacher and teacher of the word with a heavy prophetic anointing in his ministry that spiritually empowers, equips, energizes, and breaks yokes of fear and torment.

Through God, His ministry creates an atmosphere for miracles—defeating oppression, demons, addiction, and sickness.

Although Pastor Henry is a multitalented individual, preaching the word of God is what he has been chosen to do. His philosophical belief is clearly stated in the book written to the Philippians, which states, "I can do all things through Christ who strengthens me" (Philippians 4:13). He strongly believes that there is no *I can't* in Christendom, except when pride gets in the way. He is known for his charming personality and winsome countenance. Pastor Henry is a firm believer that believes it is not *what* you are in Christ, but *who* you are in Christ.

Pastor Merits Henry works diligently in the service of the Lord with his wife, Minister Rashemia R. Henry, and the dedicated members of the church. Pastor and Minister Henry are the proud parents of Raar, Ramere, and Azzan Henry.

For more information about Worship Conference Ministries or to receive a copy of this book, *The Anointing Exposes the Deeds of the Flesh,* and messages by Pastor Merits Henry, write or call.

Worship_cm@yahoo.com

PO. Box 203, KY1-1104

Grand Cayman, 1345-9245909; 1345-5476854